SACRED
SCRIPTS

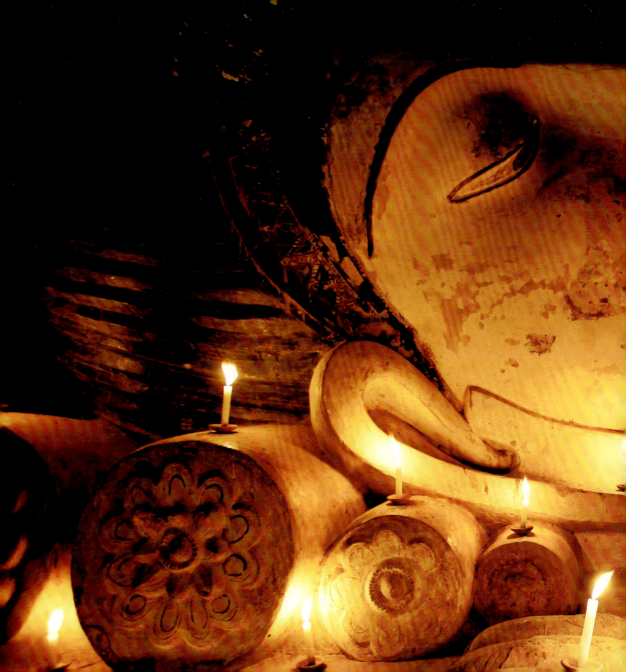

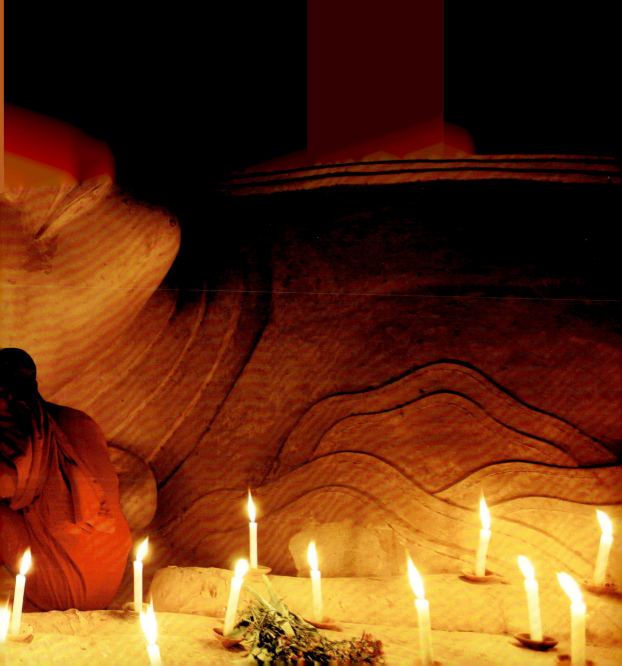

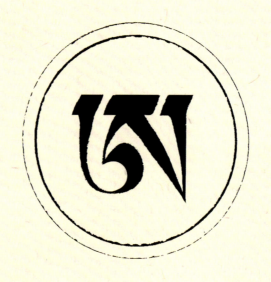

ཨ

དབུ་ཅན།

Uchen Script

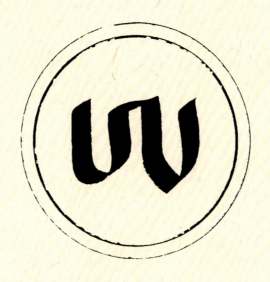

Umed Script

SACRED SCRIPTS

A Meditative Journey Through Tibetan Calligraphy

CALLIGRAPHY BY TASHI MANNOX

PHOTOGRAPHY BY ROBIN KYTE-COLES

MANDALA
PUBLISHING

San Rafael, California

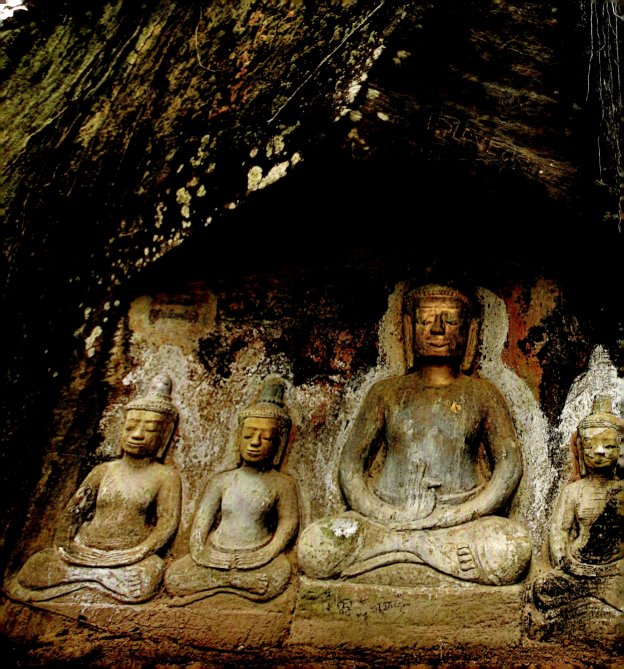

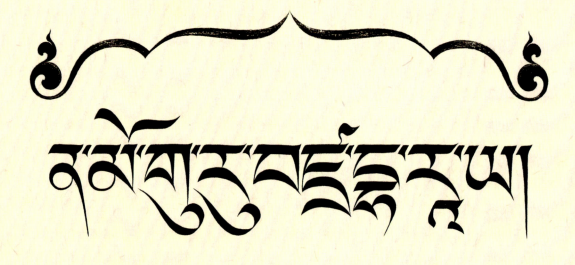

Homage to my teacher, the bearer of reality.

This book is dedicated to my teacher, mentor, and spiritual father, Akong Tulku Rinpoche. May his tireless activity in guiding all beings from the ocean of Samsara to Nirvana swiftly manifest. May all beings be happy and free of suffering.

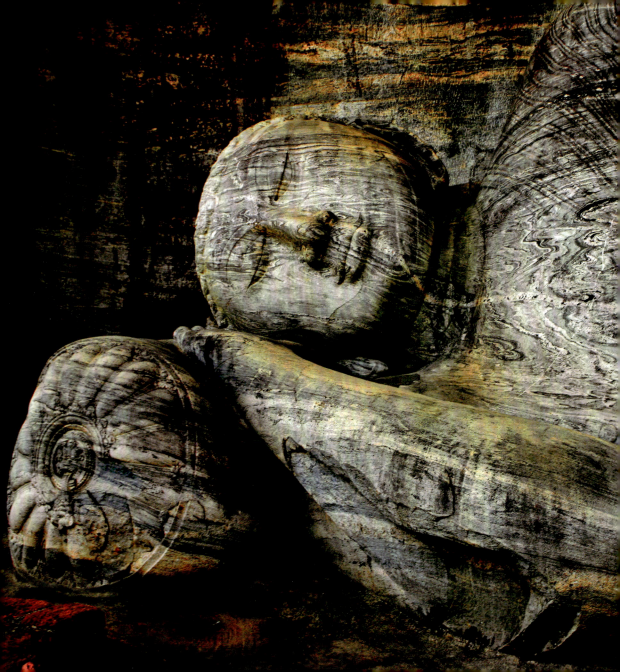

Contents

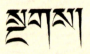

A NOTE ON TRANSLATION

The utmost sacred form of speech is mantra, which represents the ultimate or divine, not only through the quality of the sound it produces but also through its physical form. Thus, mantra practice is described as both liberation through hearing and liberation through seeing.

Within the Buddhist traditions, mantras are not considered ordinary, mundane words or phrases; their meanings, syllable by syllable, are vast and deep, so they cannot be simply and directly translated. Therefore, within this book, wherever mantras are depicted, the name of the mantra as well as its general beneficial quality is given.

Buddhist practitioners generally both recite and meditate upon mantras to transform their ordinary state of being to a more ultimate, enlightened state. Mantras are affiliated with particular deities and Buddhas, and their practice is traditionally a long process of purification and transformation. This process includes the practitioner identifying in body, speech, and mind with the ultimate enlightened state of the particular deity or Buddha through the visualization of and meditation on the form of the mantra while reciting the mantra to facilitate the balancing quality of sound.

In Tibet and other Buddhist countries, sacred manuscripts and representations of mantras are considered objects of veneration, because their metaphysical wisdom, representing the ultimate, is a means to becoming spiritually awakened. Therefore, please respect the content of this book and hold in high regard its spiritual origins.

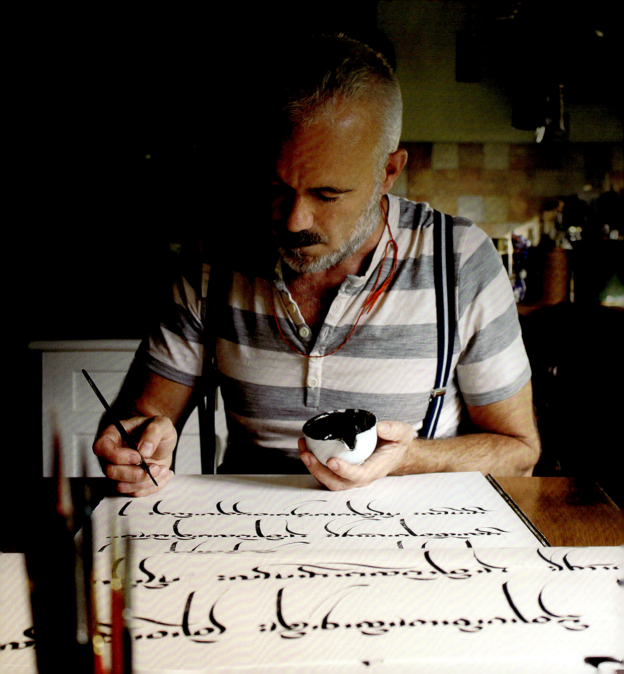

TIBETAN CALLIGRAPHY

Dominated by mountains amidst barren scree, plains, and hardy flora, the Tibetan motherland is a landscape as beautiful as it is unforgiving. Economically, the focus is on subsistence agriculture and, increasingly, tourism. Culturally, Tibet is a nation typified by an innate spirituality. Religion influences all aspects of public and private life, with most Tibetans practicing forms of Tibetan Buddhism or Bön. Writing, especially calligraphy, has long been fundamental to such practices. Given calligraphy's significant role in the religion and thus the culture of the nation, it is no surprise that Tibet houses a vast repository of religious manuscripts and calligraphic artworks despite its relatively small population.

Derived from the Greek root words *kallos*, meaning "beauty," and *graphein*, meaning "to write," calligraphy translates loosely as "beautiful writing." The Tibetan word for calligraphy, *yig zugs*, shares a similar etymology; its literal translation is "letter form." However, beautiful handwriting in and of itself does not necessarily constitute calligraphy. Calligrapher and typographer Professor R. K. Joshi defined the properties that qualify genuine calligraphic art as good handwriting with aesthetic consideration and concern regarding content and care in the act of doing, all of which is governed by a writing philosophy and perfected by dedicated practice.

A Brief History of the Tibetan Writing System

It was during the seventh-century reign of Tibetan king Songtsen Gampo, and under his direction, that the first iteration of what would become the modern-day Tibetan written language came into existence. Prior to this, Tibetans had used Mayig, a comparatively rudimentary writing system. But when Songtsen Gampo was faced with the task of translating the wealth of existing Buddhist Sanskrit texts into Tibetan, he needed a coherent writing system with sufficiently rich symbolism. He turned to minister and great scholar Thönmi Sambhota, who, along with sixteen other wise ministers, traveled to India to study Sanskrit. Only Sambhota returned. His journey had proved fruitful, however, and a new Tibetan writing system based loosely on Indic Sanskrit was established. (It is worth noting that the Tibetan spoken language remained the same; only the written language was renovated.) Sambhota had conceived an alphabet and standardized writing conventions, including grammar and punctuation, and would later also produce the first iterations of the Uchen and Umed script forms.

Different script styles developed over the next several hundred years. In the early ninth century, the Tibetan script underwent another transformation and "Old Tibetan" was standardized into "Classical Tibetan." One thousand years passed, yet Tibetan calligraphy persevered, steadily evolving toward its contemporary form. By the nineteenth century, the models of Uchen and Umed, the two main Tibetan script styles, had ossified and bore the exact proportions still in use today.

From the outset, a notable bond existed between the Tibetan writing system and Buddhism, since the writing system's creation was motivated primarily by a need to conserve and decipher Sanskrit Buddhist manuscripts. To limit the connection of calligraphy and Tibetan Buddhism (and by association Tibetan culture) to a functional conception, however, does not do justice to the depth of their relationship. The two are largely inseparable and have remained so to the present day. Tibetan Buddhism is considered a living tradition composed of many lineages in which a master will impress the totality of a line's knowledge on a disciple. The lineage is also considered fluid, as the disciple then realizes the wisdom of these teachings through meditation. The academic and meditative aspects of Tibetan

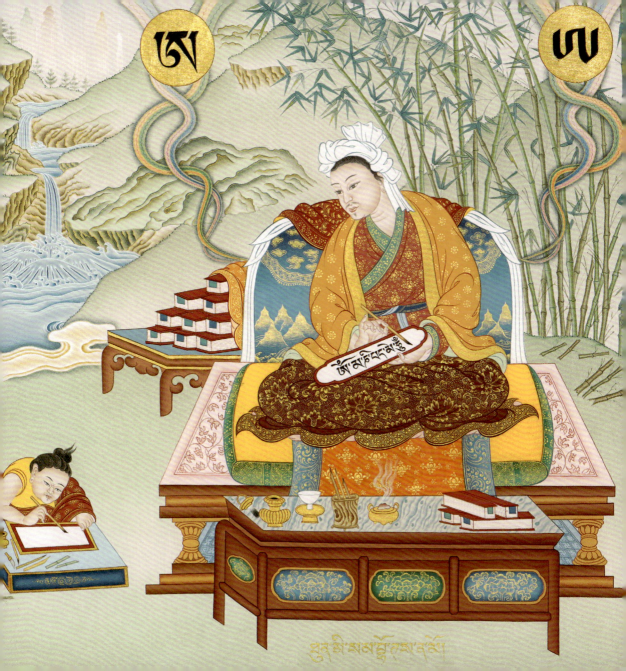

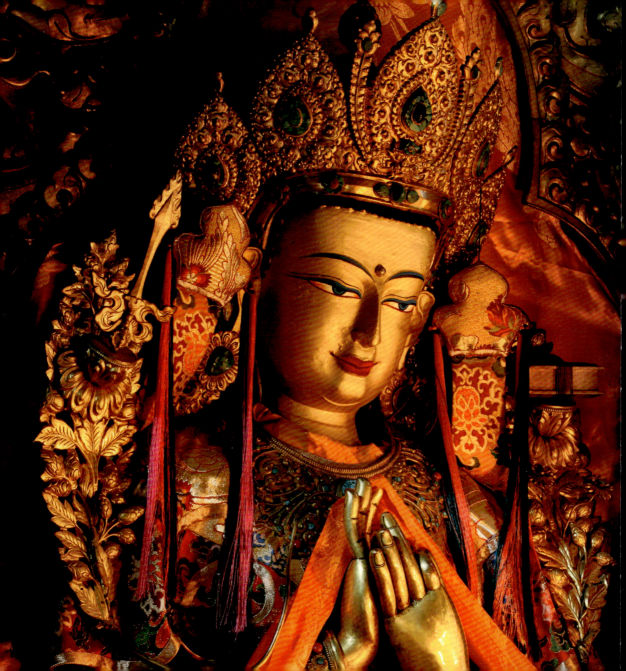

Buddhism are closely linked, and calligraphy's role in this relationship as a key by which existing Buddhist teachings are unlocked further compounds the art form's importance.

In Tibet, monasteries have long been the economic, political, and cultural centers of the community. Monasteries did, and still do, house large collections of books and manuscripts. These texts, often venerated objects in their own right, play a role in the daily practice of recitations. Historically, monasteries were also the only institutions offering education; monks taught philosophy, art, and astrology in addition to instructing on religious practices. As such, monasteries were the only means by which lay Tibetans could become literate. Becoming a monk or a nun was accessible to all Tibetans, regardless of social status or wealth. Parents would often offer their third child to the monastery, where they would be raised and educated. These children often remained in the monastery for the rest of their lives. Those who became calligraphy students underwent rigorous training for ten to fifteen years, spending at least a couple years on each script style. High lamas and other nobles were also adept calligraphers.

But why study calligraphy? As a meditative discipline, calligraphy aids in taming both the body and the mind. It also hones an appreciation of design, letterform, and composition. These days, far fewer people possess calligraphic training than in the past. As is the case with most world languages, handwriting has given way to computer fonts, even in Tibet. To become a Tibetan scribe in the East today, one may still train in a monastery in addition to studying in schools and universities. In the West, however, there is very little instruction available: Institutions such as the School of Oriental and African Studies at the University of London and Naropa University in Colorado teach the Tibetan language, but not specifically the art of calligraphy. However, with the increasing popularity of Tibetan Buddhism, there is an emerging interest in learning the art form of calligraphy. Western Buddhists may practice calligraphy as part of learning the language and as a means to access the wealth of wisdom contained within Buddhist manuscripts, only some of which have been translated into Western languages.

At its foundation, the act of creating calligraphy is a purposeful endeavor that is not only a physical technique but also an expression of the heart and the mind. This artistic approach,

in which the artist assumes a meditative state, is known as dharma art, and was pioneered by Chögyam Trungpa Rinpoche. In dharma art, there are no right or wrong outcomes, no separation of artist and audience, no intentions and no consequences. The art *is* the process. One should have no fear of failure nor expectation of praise. In the Buddhist concept of realization, one progresses toward clarity and emptiness.

CALLIGRAPHY AND ITS TECHNICAL FEATURES

In addition to the artist's mindset at the time of creation, one must take numerous other technical factors into account. Traditional Tibetan calligraphy—as is the case with calligraphy in many other countries—is made with black ink on white paper with a red seal. The seal commonly uses cinnabar ink, which is made from a hand-ground mineral. Cinnabar was also historically used as blusher until its toxic qualities were discovered. For a writing implement, a practitioner may use anything from the traditional hand-cut bamboo pen to modern brushes, with contemporary calligraphers utilizing any object that gives the desired effect. Ink is traditionally black, with Japanese and Chinese inks among the most popular. These are often derived from soot and include extra ingredients such as camphor, which gives the ink a sweet, musky scent while also helping to preserve the characters. Traditionally, laid Lokta paper was used, a parchment derived from a species of Daphne shrub. Its durability and insecticidal qualities made it the preferred choice for recording official government records in the Himalayan region.

Proportions are crucial in calligraphy: both of letter constituents (the height and width of curved or straight lines and their joineries) and of the relation of a letter or words to blank space. The pressure applied is also critical, in addition to a variety of other technical factors too numerous to list here.

The Tibetan written language falls into two main categories: Uchen and Umed. The former, Uchen, is commonly used as a formal style. It possesses a header line at the top of each letter, as in the Indic Devanagari script, and for this feature it is often mistaken for Sanskrit. Unlike the Umed script style, the main body of each letter in Uchen is based on a geomantic grid of nine

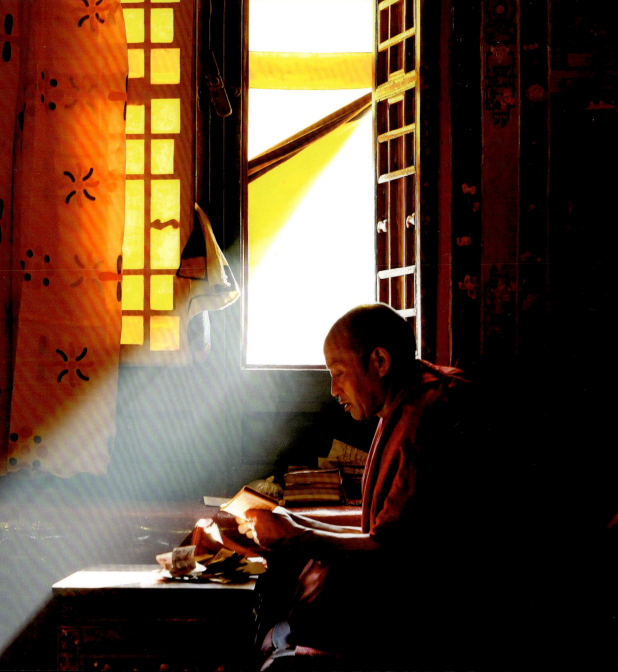

boxes. This allows for a more precise construction of the letters, which aids in adhering to the divine proportions of this script style's conventions. The angular character of the letters is well suited for carving into wood blocks, the traditional method for printing the scriptures.

The latter, Umed, is a class of styles, all of which have no head. Originally, Umed was conceived as an alternative to the more precise Uchen script, since Uchen is slower to construct and less economical in terms of valuable paper space. Umed is more specifically a handwritten style. Under the umbrella form of Umed, a variety of styles have developed for different uses and across geographical regions. Outlined below are just some of the main Umed styles.

Tsugring, also known as Druchen or "long style," is the foundation on which all other Umed styles are based. It is traditionally the first style to be learned by students, who use dusted wooden slates with water as an ink substitute. Only when this practice is perfected can the students graduate to paper and ink. Tsugring's long tails demand a steady hand, thus it lends itself well as an exercise for trainee monks and nuns. Its impressive characters mean that it is commonly used for official documents.

Tsugtung, or "short style," is practiced next. Its name translates as "short form," and, compared to the Tsugring, it has shorter overall letter height.

The script style Petsug is named according to its common use, with "pet" translating as "books." Its other name, Khamyig, refers to Kham, the place of the script's origin in East Tibet. It has very short letter height, allowing many more rows of text per page. More commonly used for religious texts, Petsug is also seen in epics, stories, and special ritual manuscripts. For brevity, this script style abbreviates some common terms to single words.

Tsugmakhyug has the same shape as Tsugtung but is smaller and more rounded stylistically. It lies between short style and the fast handwriting style known as Khyug. Khyug is a ubiquitous handwriting style in Tibet, used for note-taking and most day-to-day activities.

Finally, there are ornamental styles, such as Drutsa, which are often used for book titles and important documents. The long graceful lines and flamboyant gestures of this style go well with more artistic and expressive uses of calligraphy. Countless subdivisions of the various script styles also exist.

Calligraphy was historically used in the creation of historical, legal, and administrative documents, as well as in many religious texts. Some notable examples of sacred writings commonly calligraphed include the Sutras and Tantras, which comprise the entire teachings of the Buddha (the former refers to his discourses and the latter to his writings). Also calligraphed are traditional mantras, the highest sacred form of the written word. The divine quality of mantras resonates not only through the properties perceived by the ear but also through the sacred proportions of the letters and words when seen through the eye. Venerated for the metaphysical wisdom they enable, mantras are the ultimate catalyst for becoming spiritually awakened. Further, ritualistic use of calligraphy is also common, including creating sacred monograms and seed syllables (certain individual sounds) for use in meditation. Contemporary calligraphers in pursuit of exceptional subject matter continue to return to this type of sacred writing.

Tibetan Calligraphy as Art

Historically, calligraphy as an expressive art form was rarely practiced in Tibet. Upholding the practice and preserving the conventions of calligraphic script took precedence over individual expression. Nonetheless, creativity was encouraged within the boundaries of the tradition.

Notable among calligraphic innovators is the aforementioned Chögyam Trungpa Rinpoche. He pioneered a modern approach to calligraphic art during the 1970s, one that underlined the importance of process yet allowed for freedom of expression. As an artist, he was influenced heavily by the Zen aesthetic and its meditative approach. According to Trungpa:

> *Venerating the past in itself will not solve the world's problems.*
> *We need to find a link between our traditions and our present*
> *experience of life. Nowness, or the magic of the present moment,*
> *is what joins the wisdom of the past with the present.*

Trungpa's application of this philosophy to calligraphy, whereby the process is manifest in the expression, shifted attitudes and contributed to Tibetan calligraphy's modern status as a conventional art form. While the "proper function" of calligraphy is disputed, the plurality of its use continues to develop in the modern age. Calligraphy can be functional, expressive, aesthetic, or even ritualistic. Formalists argue that characters should always possess proper form so that they truthfully represent themselves and their relation to one another. Nonetheless, respectfully, the calligraphic tradition is evolving. Modern practitioners are innovating their tools and techniques and exploring variations in form, expression, and composition. Primary to any act of diversification is that it be done without harming the integrity of the ancient tradition.

Conservation of the Tibetan Language

Academics estimate that roughly half of all languages could be lost by the end of the century, with over three thousand currently considered endangered. The Tibetan language, in particular, unlocks a wealth of wisdom given the number of Tibetan Buddhist texts in existence. For example, the complete 108 volumes of the Buddha's teachings in the Kangyur and the 224-volume commentary on the Sutras and Tantras in the Tengyur are available in Tibetan, whereas many of the original Sanskrit volumes have been lost. The continued practice and conservation of the Tibetan script styles is critical in order to retain this ancient sacred knowledge. The discipline of a trained hand is fundamental to both the issue of conservation and the proper diversification of calligraphy as an art form. Calligraphy, while keeping scriptural traditions alive, also provides a firm artistic foundation that allows practitioners the confidence to let their creativity freely emanate through the medium.

Within this book, readers will find a selection of master calligrapher Tashi Mannox's recent work, created exclusively for these pages. The pieces incorporate a range of Tibetan script styles, and though grounded in the conventions of the tradition, the artworks employ contemporary compositions and techniques. Buddhist quotes, phrases, and mantras are all expertly calligraphed. The aim of the work here is to inspire and uplift the reader, while its publication will contribute toward the continued preservation of the Tibetan written language.

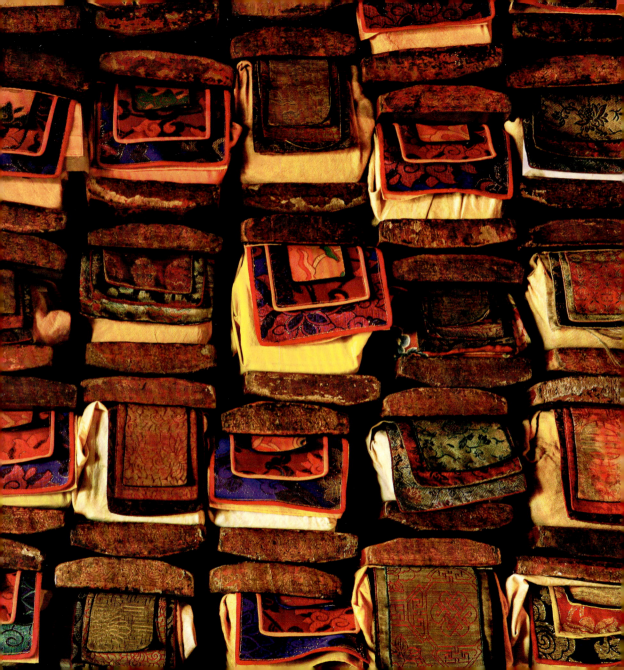

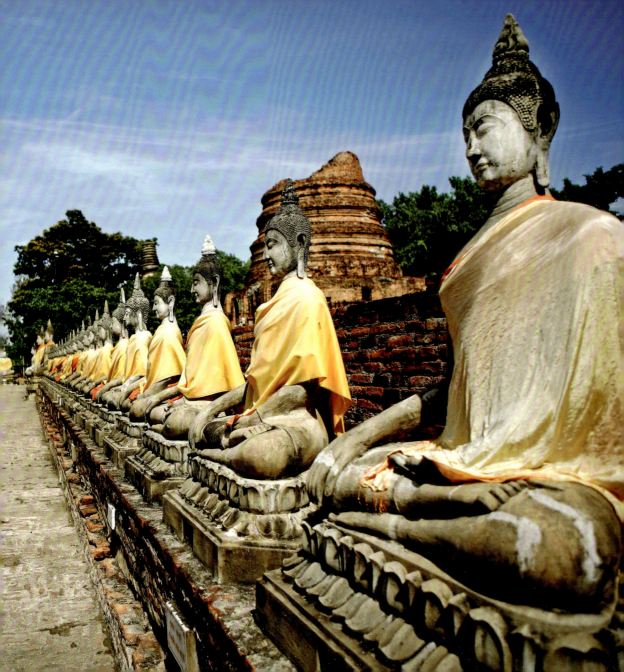

PHOTOGRAPHER'S NOTE
BY ROBIN KYTE-COLES

I have not always been a photographer. I used to have a chain of shops, and I was a wholesaler of world handicrafts. That work took me all over the world and introduced me to many cultures, but I was always drawn to Buddha images and figures. I wasn't spiritual at the time and didn't know anything about Buddhism in particular, but to me, the image of the Buddha always seemed to have a unique sense of serenity and contentment. I'm an active, all-over-the-place kind of person, and I think I wanted to share in the sense of the Buddha's peace. As I was going through a divorce, I turned to spirituality for guidance and started to study Buddhism, among other spiritual traditions. I came to believe in the original philosophy of Buddhism and learned that it includes good guidelines for living a happy life.

I eventually made a bit of money and asked myself, *What do I want to do? What would make me happy?* I'd always loved photography and had considered myself an amateur photographer, but with this windfall came an idea: I'd go to Asia with my then-girlfriend (now wife) and, to avoid being a dreaded "tourist," would turn my trip into a project. I'd take pictures of Buddhas, the figures that had fascinated me for so long and that I had just recently begun to learn about, and eventually I'd turn those photos into a book. I wrote to the Dalai Lama to explain this idea and to see if he could help me in any way, and, by some miracle, he wrote back and provided me with a letter of introduction to get into temples throughout Asia. Then, letter in hand and all of our unwieldy photography equipment packed, we set off for Asia to go take some pictures.

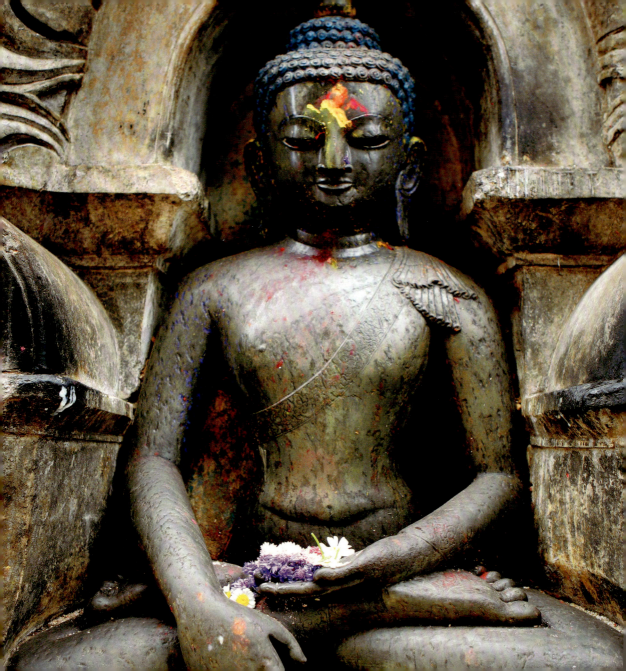

We went to many, many countries. It was not a relaxing experience, but it was an adventure. Much of it was improvised, and my girlfriend and I had fun even when things didn't go our way. As we traveled around, I was struck by how much the image of the Buddha changed from one location to the next, but even more so, over time. The older Buddhas were often hand-carved out of wood or stone and rather plainly made and decorated, while the modern ones were cast from metal and generally quite extravagant. I, personally, have a preference for the more subtle antique Buddhas. There is a certain atmosphere in older temples and within antique figures that the modern versions just don't capture.

Out of all our destinations, I have a few favorites: Ladakh in northern India, on the edge of the Himalayas, stands out the most in my mind years after I traveled there. It's where the Dalai Lama goes during the summer. The ancient Ladakhi temples have serene, meditative atmospheres. The light shines through the ancient windows and filters through the dust, shining on the monks and the multicolored books. Many of the modern temples were lit with neon lights, which we had to take down and replace with our own "natural" lighting, using reflectors and other equipment. That wasn't the case in Ladakh. One day, during morning prayers, we sat cross-legged in the back of a temple and watched the monks chant for hours. Sitting with the monks that way took us on a strange, beautiful, meditative journey. It was incredible, and I hope I captured it in my photos, but, to be honest, I was so caught up in the moment that I didn't take as much care as I probably should have with the technical details. One of my favorite Buddhas in this book, the Maitreya Buddha, the Buddha of compassion, was photographed in Ladakh.

Tibet was amazing but also quite sad. Over a thousand temples have, tragically, been destroyed over the last century. The remaining Tibetan temples were beautiful and worth all the trouble required to get to them. Tibet, in every way, lived up to its reputation as a center of Buddhist art, culture, and education. I was amazed at the staggering repositories of ancient books and works of art, and the ethereal temples transported me far into the past.

We also went to Nepal, and many of the photos from there are of hundred- or thousand-year-old temples and Buddhas—many of which don't exist anymore after the 2015 earthquakes.

Burma was fabulous. The Burmese take Buddhism very seriously, but they also gave us a lot of freedom. The monks even helped us by holding the fold-out reflectors to shine natural light onto the Buddha statues while we were photographing them. In other places, it didn't always go so well. In Thailand, we had a bit of trouble with the police: We had a stepladder, and we started to climb higher than the Buddha statue, which caused a bit of a stir. They made us leave, but not before we got the picture.

Most of the time, the people and monks we met were incredibly nice. We did meet some people who were aggressive and unfriendly, but this was mostly in response to foreigners breaking Buddhas or defacing the temples. I imagine that a number of the places we went have since changed—either the Buddhas themselves or the rules about going into the temples—because of this wanton vandalism.

If I could, I'd go back in a heartbeat. I'd like to go to new places, too—perhaps Japan—but I'd also like to revisit Burma, because there were a number of political issues that affected our time in that country. I wish we could have stayed longer in certain places, too. Often, a photographer will stay in one place for a week or a month to get just the right lighting at just the right moment, but we were always on the go and trying to cover a lot of ground, so we had to make do with what we could get quickly. It wasn't always easy, but it was always worth it, and I couldn't have done it without my darling wife, Alex.

Even if people don't read this whole book, I hope they will look at the images and take a moment from their day to breathe and think, *That looks peaceful.* And I hope they will be motivated to look at the philosophy behind Buddhism, to find the source of that contentment. I'm not asking people to become devout Buddhists—I certainly am not—but if this little book is enough to get people interested in looking into this beautiful, peaceful philosophy or taking some time out of their day to meditate and reflect on their lives, that's the best result I could ask for.

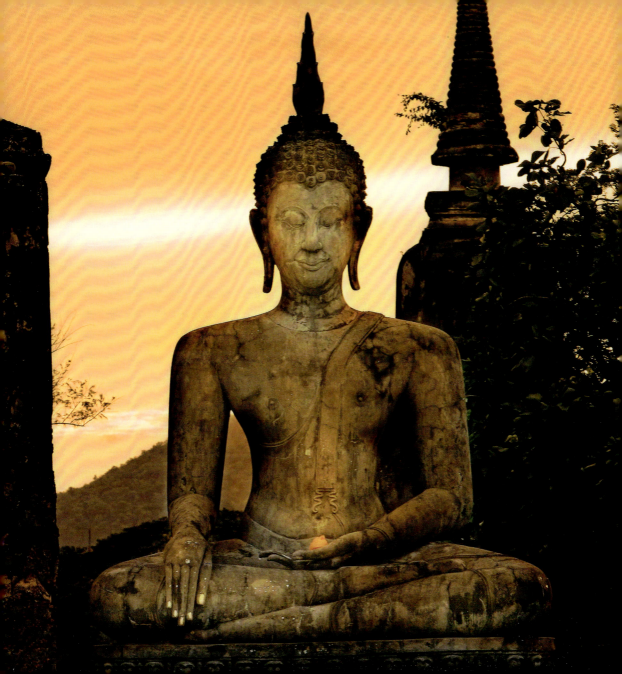

The
Sacred
Script

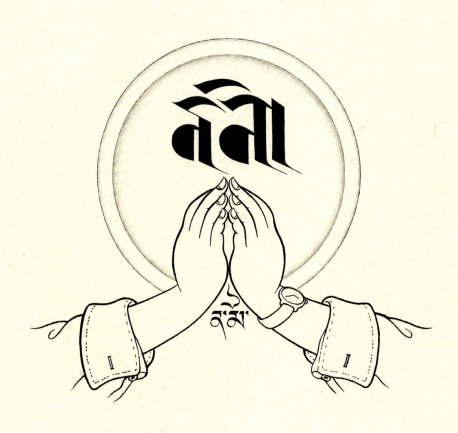

Homage

Homage to Buddha Shakyamuni

ༀ། །ཁྱབ་བདག་རྡོ་རྗེ་འཆང་ཆེན་དགའ་བའི་ཁ་བཤད།།

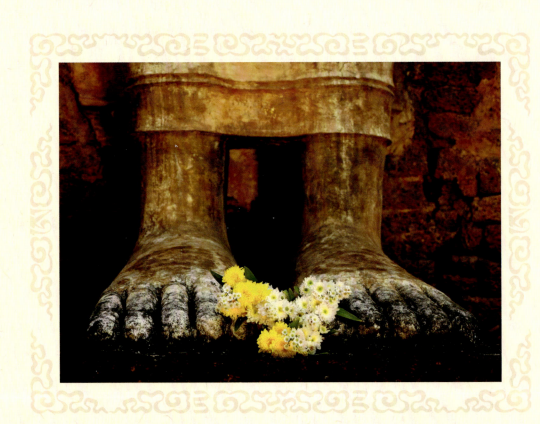

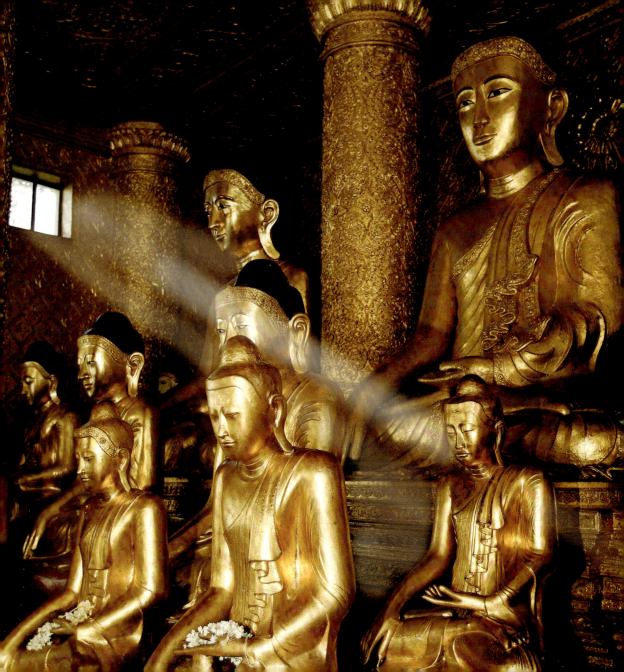

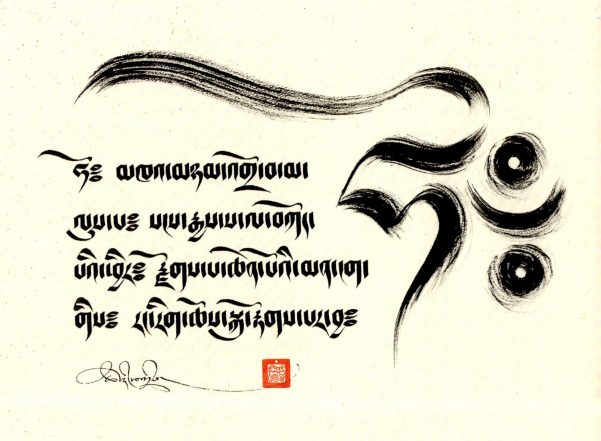

ho

In order to establish all beings equal to the sky;

In the state of buddhahood;

I will realize the dharmakaya

of self-existing awareness;

Through the teaching of the Great Perfection.

The aspiration to help all beings
to enlightenment is Bodhicitta.

ཤེ་བ་ཤ།

གུང་སེམས།

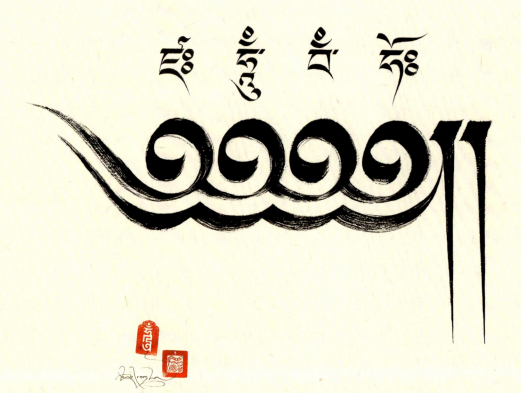

dzaḥ hūṃ baṃ hoḥ

Invocation Heading

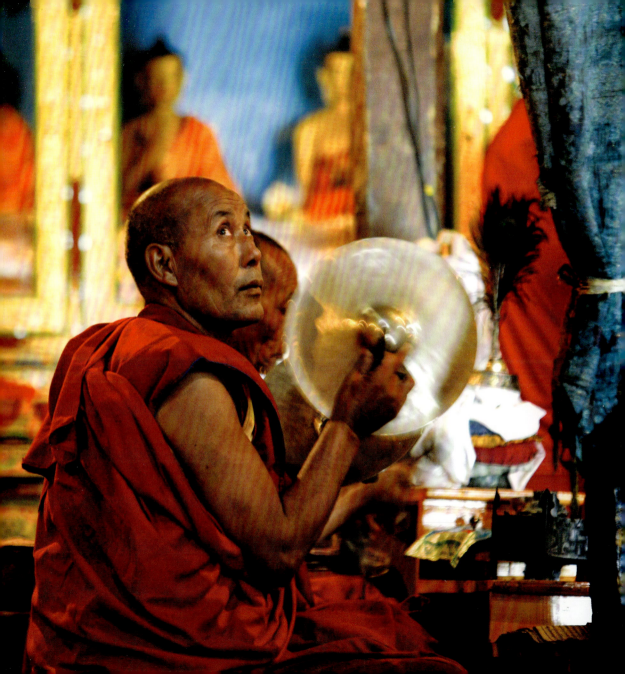

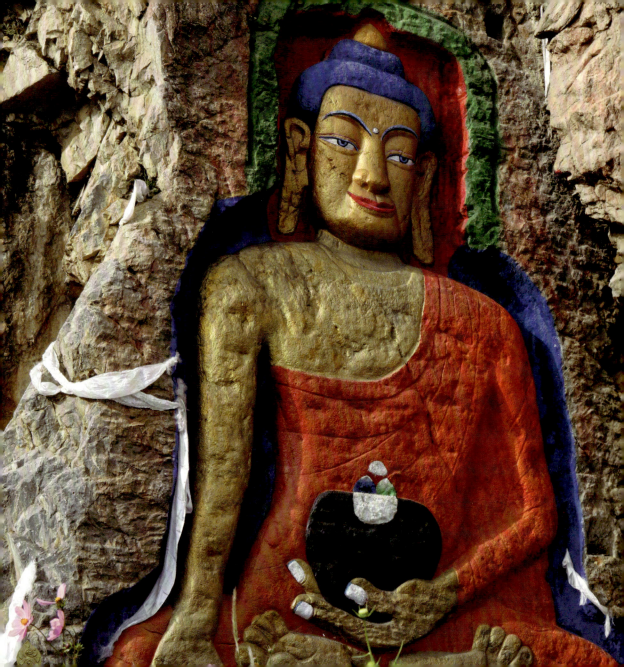

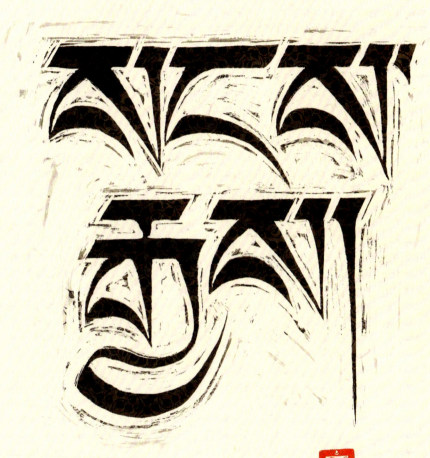

Awakened

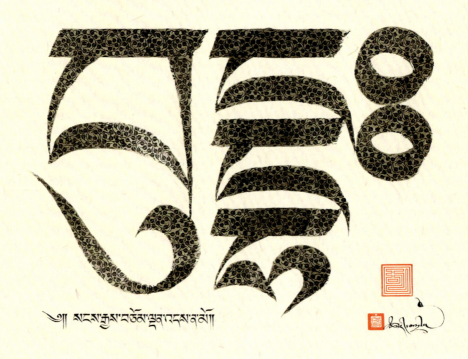

ༀ། སངས་རྒྱས་བཅོམ་ལྡན་འདས་ན་མོ།

Buddha

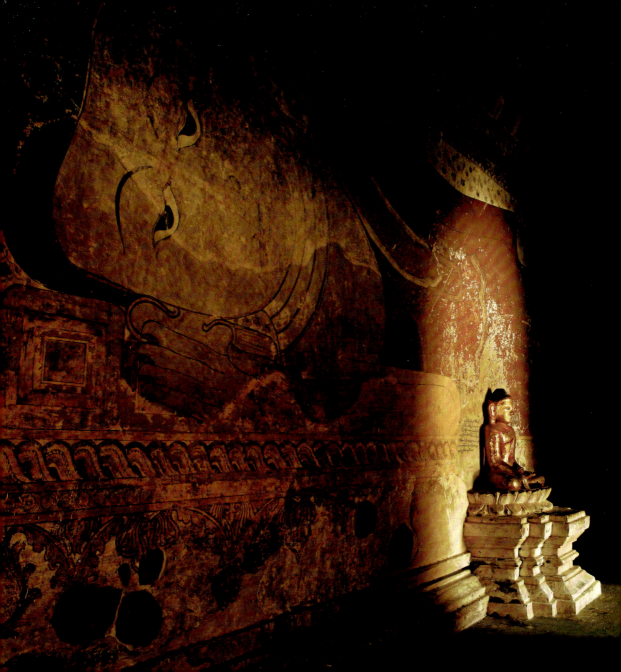

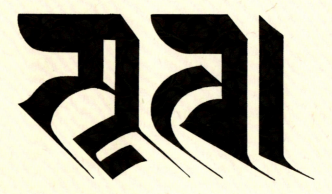

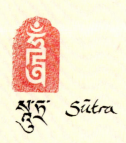 Sūtra

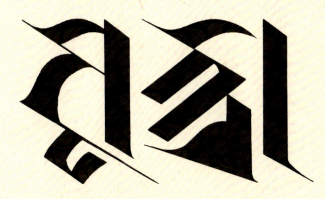

ཡི་གེ་པ་གུརུམ། ཡི་གེ་པ་ཙ་ག་པ།

ཡི་གེ་པ་ཀ། ཡི་གེ་པ་ཡག་ག་ཤ།

ཡི་གེ་པ་ག་ཚིལ། ཡི་གེ་པ་ཚ་ལ།

ཡི་གེ་པ་ག་ལ། ཡི་གེ་པ་ད་ཟ།

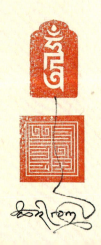

Right view

Right intention

Right speech

Right action

Right livelihood

Right effort

Right mindfulness

Right concentration

— The Eightfold Noble Path

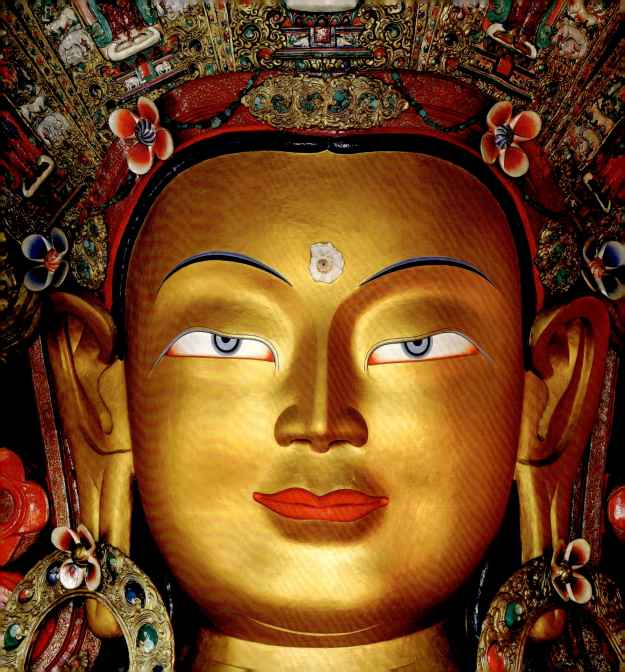

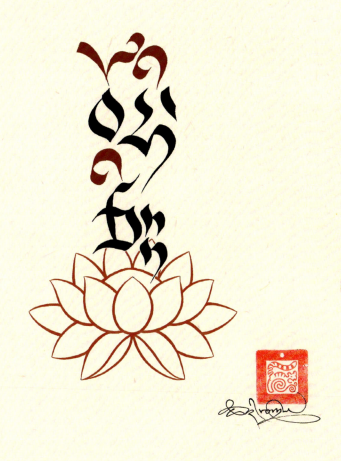

Bodhicitta

ཁ་ལ་ག་ཆིག་ཤེས་པ།
ལ་ནི་འཛུལ་ལ་ལ་ལད།
ཁ་ལ་ཐེ་ག་ཆིག་ཤེས་པ།
ཀུ་ཚུ་ལ་ལག་ལ་ལག་ག།

A Tibetan Proverb

It is better to sing a song with good heart

Than to recite Mani mantras with bad intention.

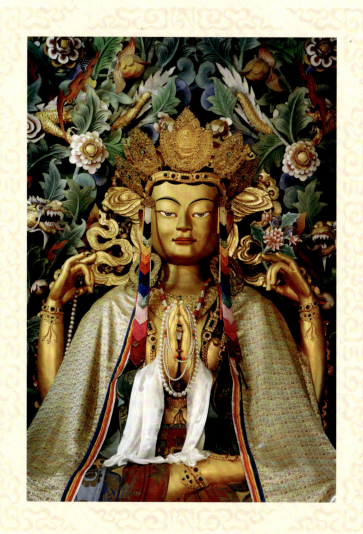

To avoid all wrongdoing;

To engage in all virtuous actions;

To tame your own mind;

This is the teaching of the Buddha.

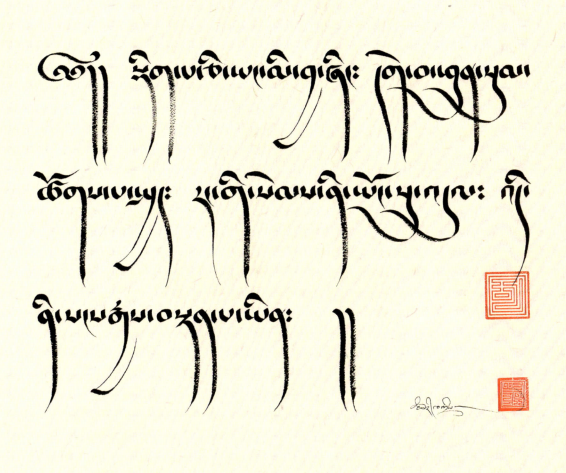

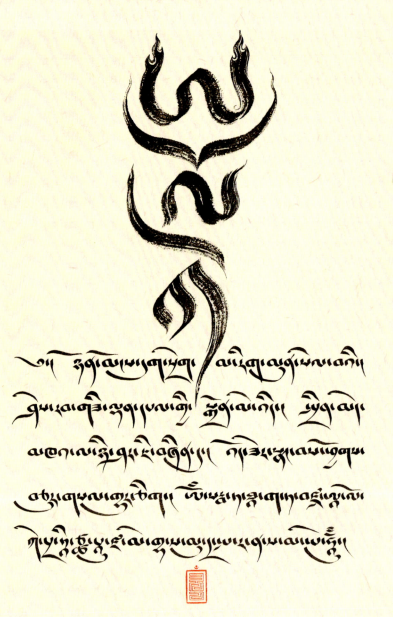

Burning up misery and poisons,

Clarifying the darkness of ignorance,

This glorious light of blazing wisdom,

Like the shining sun in a cloudless sky,

Light rays blaze throughout the ten directions, bringing clarity.

— Light Offering Prayer

This most excellent incense with blessings of meditation, mudra, and mantra,

Through this glorious smell pervading the Buddha realms,

May the ocean of Buddhas be delighted.

— *Incense Offering Prayer*

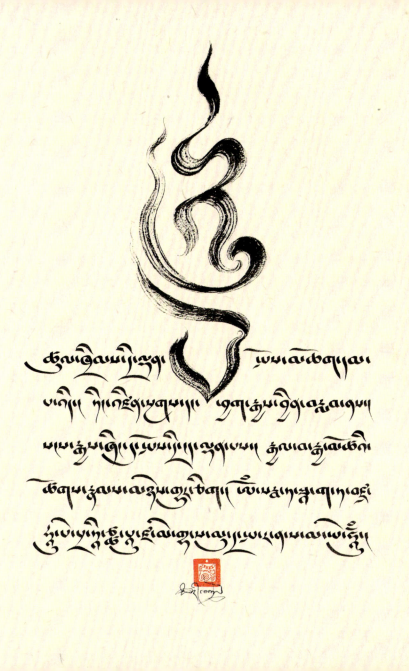

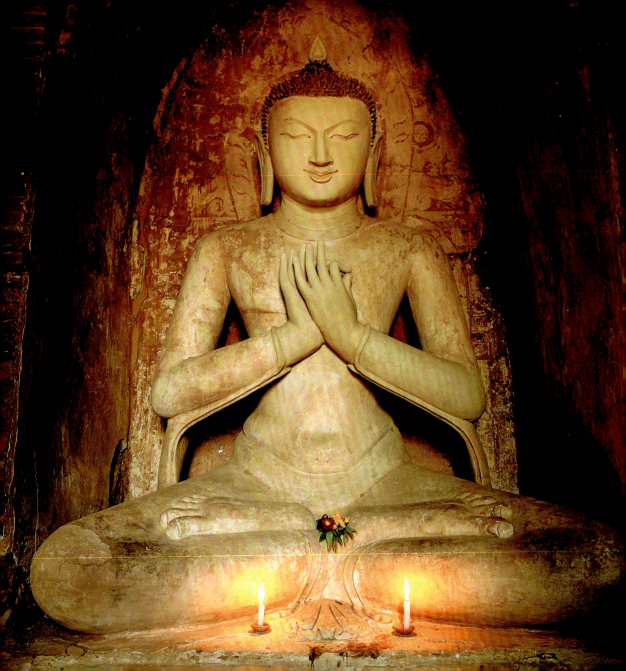

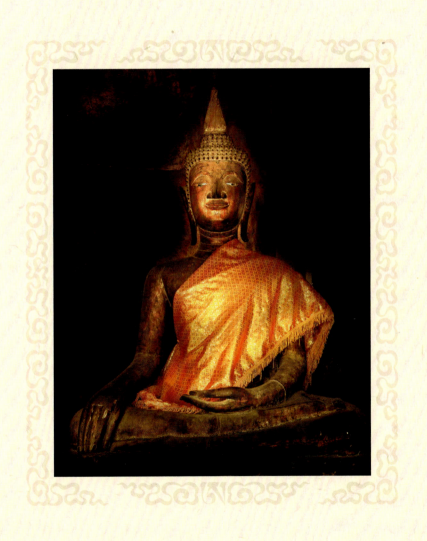

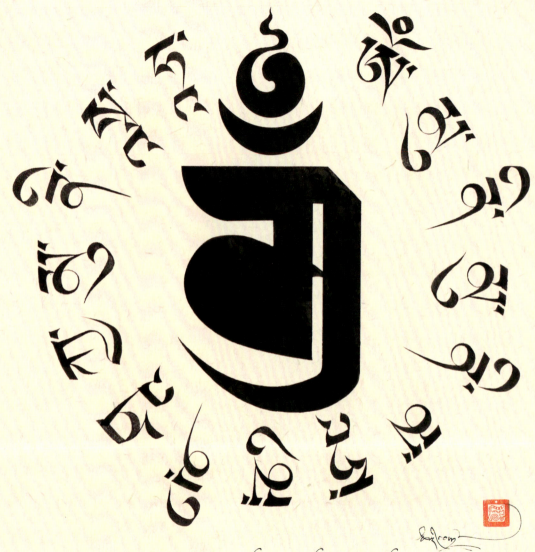

oṃ muni muni mahāmuni śakyamuni svāhā

—*Shakyamuni Mantra*

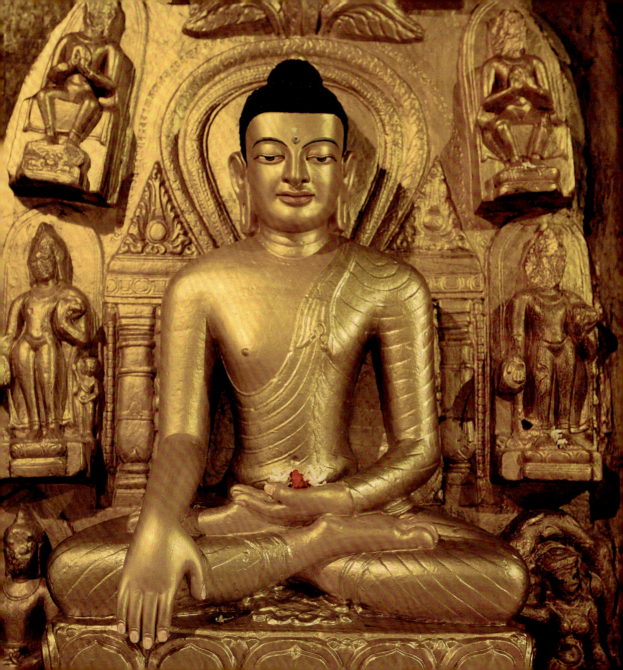

ঀৄৄৄ

Victorious

om muni muni mahāmuni śakyamuni svāhā

—*Shakyamuni Mantra*

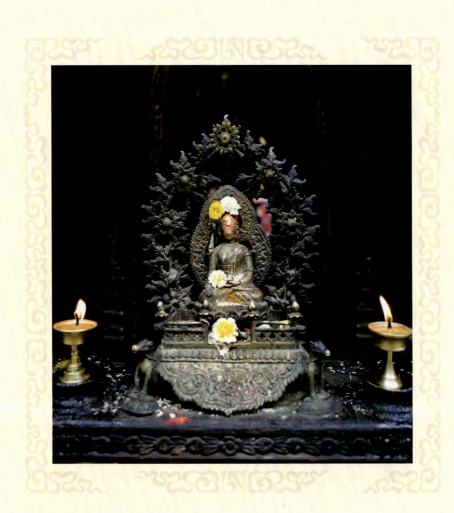

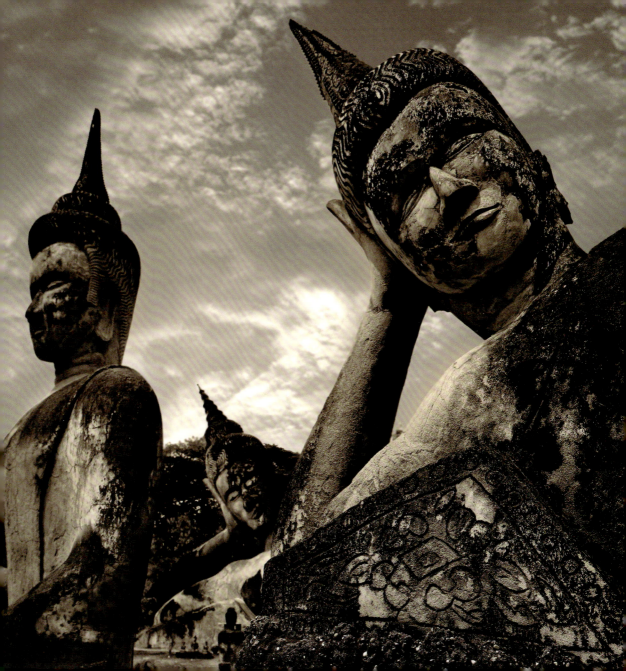

Wisdom and Compassion

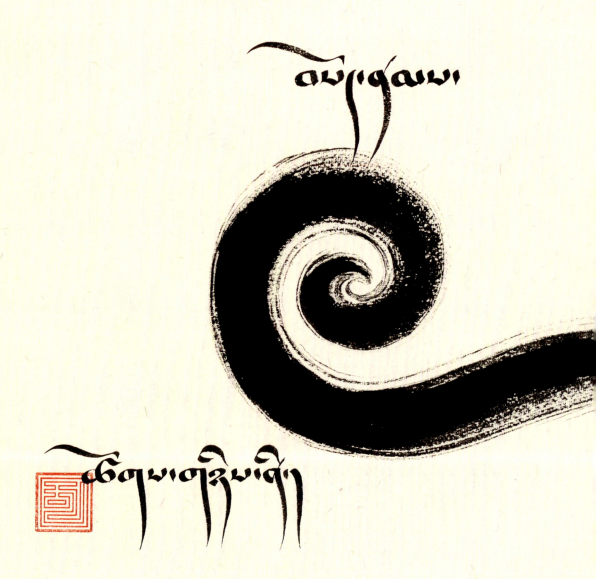

Merit

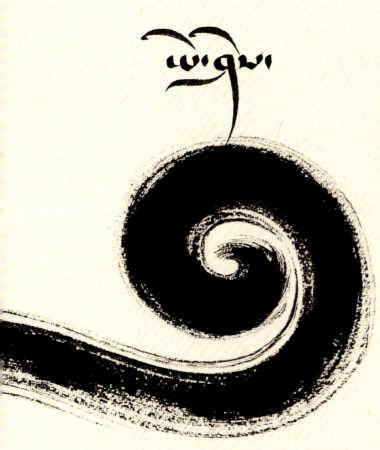

Wisdom

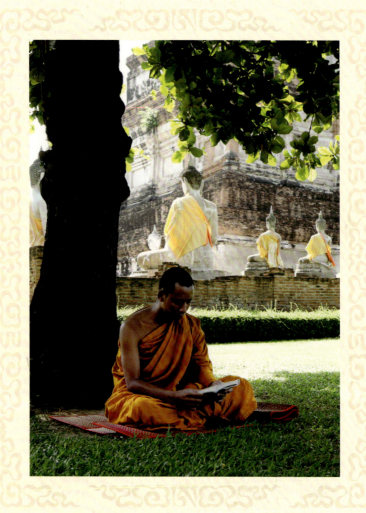

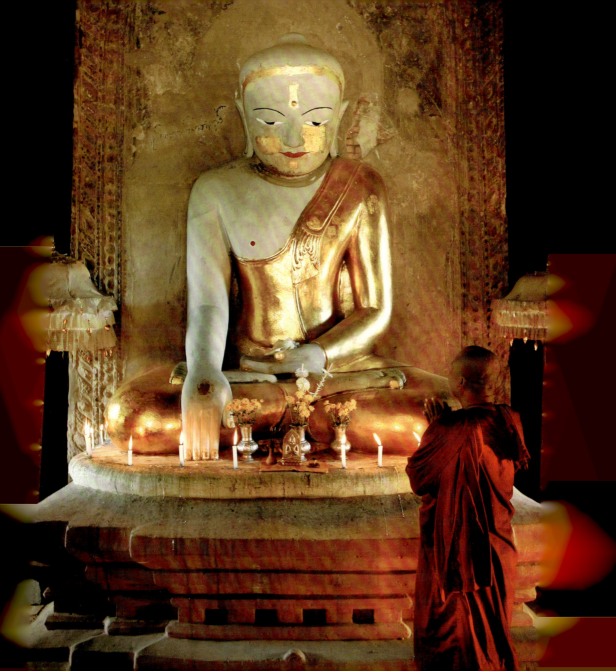

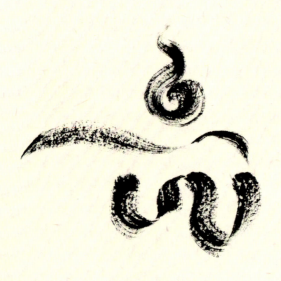

oṃ

Blessing of Body

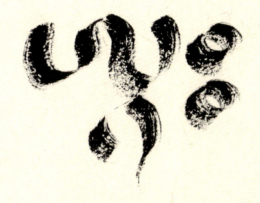

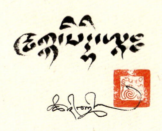

āḥ

Blessing of Speech

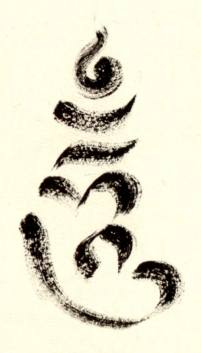

hūṃ

Blessing of Mind

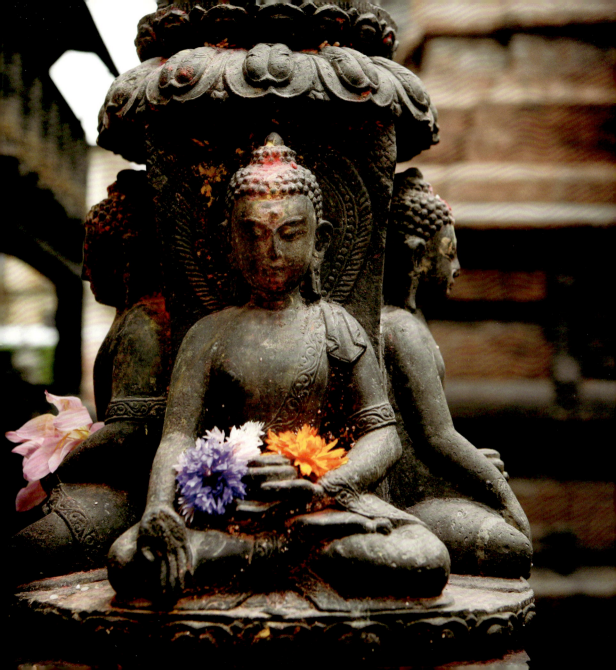

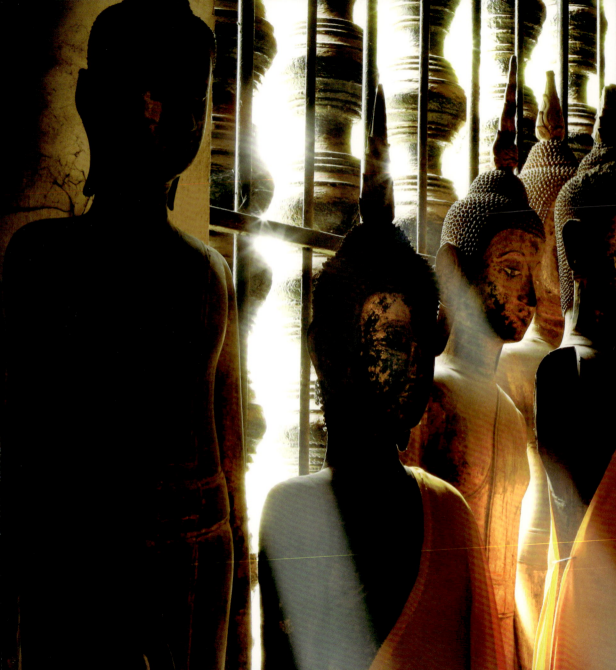

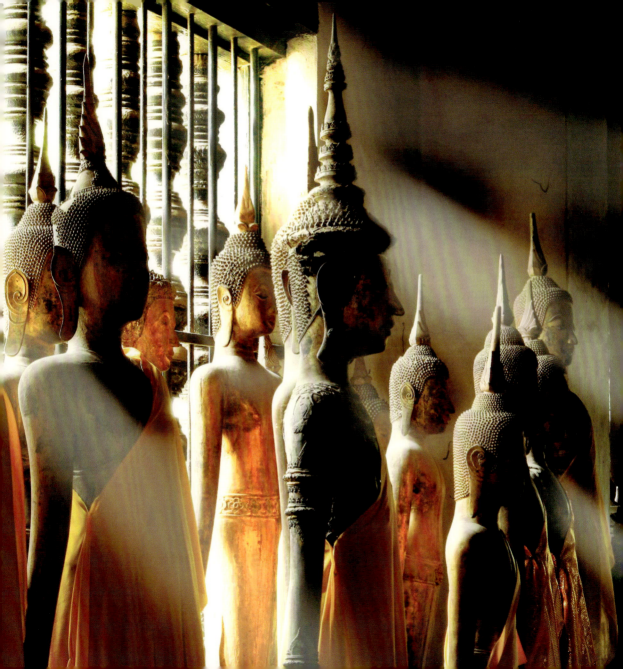

Love

Compassion

Joy

Equanimity

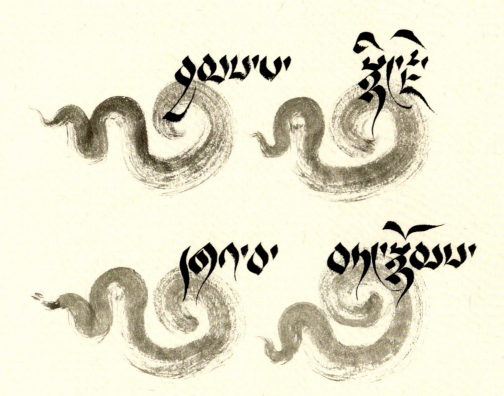

༄༅། །རྫོགས་པ་ཆེན་པོ་ཡིན་པ་ར་ངེས་ཤེ།།

རྒྱུ་མ་ཆེན་པོ་ཡིན་པ་ར་ངེས་པ།།

ཨེ་མ་ཧོ་སངས་རྒྱས་ཁམས་ལ་ཕྱག་འཚལ་ལོ།།

བཀའ་དྲིན་ལ་གཏེར་པ་བ་ཡིན།།

An awakened mind is free from fear; is steady and does not wander; is not attached to good or bad.

— *The Dhammapada*

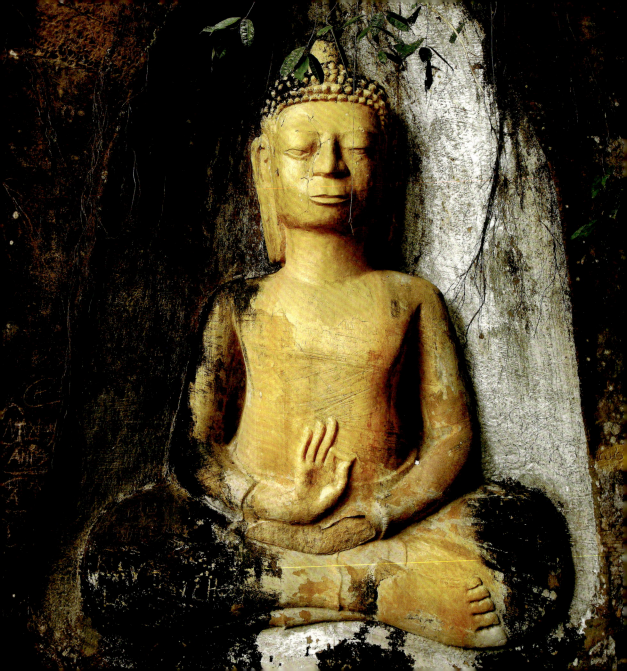

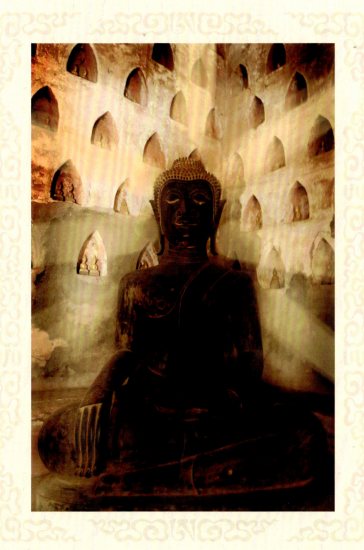

Mind

The past mind has ceased, is destroyed;

The future mind is not born, has not arisen;

The present mind cannot be identified.

— *Pema Karpo, A Record of Mahāmudrā Instructions II,*

translated by Peter Alan Roberts

ཀྱེ་ལ་གསུང་བའི་ཆོས་འདི་ནོ། །

ག་ཤུ་གུ་གྱི་ག་ཡོ། །

འཛལ་ལ་ལ་ཤུ་ཤ་ག་ལ་ཡ། །

ག་ཤུ་གུ་གྱི་ག་ཡོ། །

ཡོན་ཀྱི་ལ་ཚོ་རྒྱ་ལུ་ཤ། །

ག་ཤུ་གུ་གྱི་ག་ཡོ། །

Where did the Samsara that you dreamed of come from, and where did it go?

Where did Nirvana, the elimination of Samsara, come from, and where did it go?

They and everything else were dream phenomena.

Where did they come from, and where did they go?

— Lama Shang, *The Ultimate Supreme Path of the Mahāmudrā,*

translated by Peter Alan Roberts

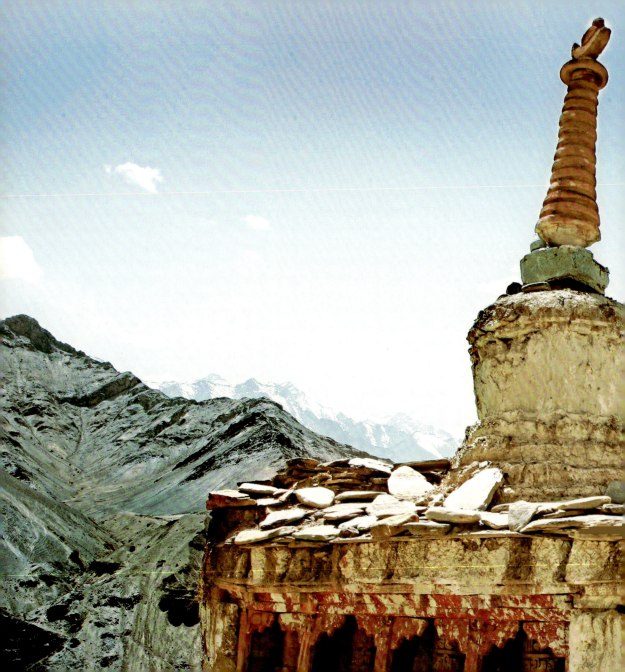

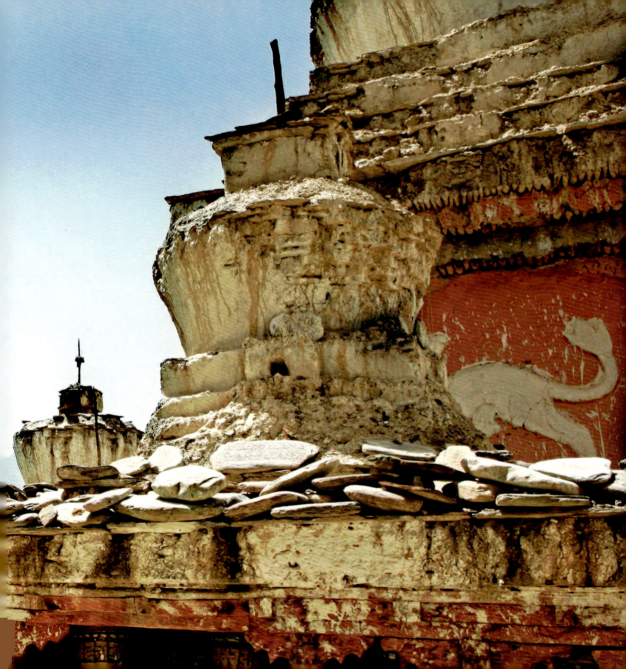

ཇི་ལྟར་ཊི་ཞིམ་མེད་པ་ཡི།
མེ་ཏོག་མདངས་ལྡན་ཁ་ཛོས།

པ་བཞིན། རང་ཉིད་དེ་ལྟར་མི།

བྱེད་པ་ཡི། ལེགས་པར་སྨྲས།

པ་འབྲས་བུ་མེད།

Fine words, which are not acted upon, are fruitless,
like beautiful flowers that have no fragrance.

— The Dhammapada

ཇི་ལྟར་རྗེ་ཞིམ་ལྡན་པ་ཡི།

མེ་ཏོག་མཚར་སྡུག་མཛེས་པ།

བཞིན། རང་གིས་དེ་ལྟར་བྱེད

པ་ཡི། ལེགས་པར་སྒྲུབ

པ་འབྲས་ཡོད་འགྱུར །

Fine words, which are acted upon, will bear fruit,
like beautiful flowers that have both color and scent.

— *The Dhammapada*

The nature of mind is and always

has been Buddha;

Like space, it has neither birth nor cessation;

When realizing the real meaning

of the equal nature of all things;

To remain in that state without

searching is meditation.

— Garab Dorje, The Nature of Mind

ༀ། །མཁའ་ཁྱབ་ཀུན་ཁྱབ་རྒྱལ་བ་ཀུན་དངོས་རྗེ།

།མཁའ་ལ་ཉི་ཟླ་ཤར་བ་ལྟ་བུར་ལྷགས།

།འཁོར་གྱི་འཛིན་རྟོག་འགལ་ཀུན་སངས་པའི་ཚེ།

།ཐ་མལ་ཆོས་ཉིད་སྟོང་གསལ་རྣལ་མ་ལྷགས།

༈ །དགའ་ལྡན་བླ་མ་དགྱེས་པ་ལ༎

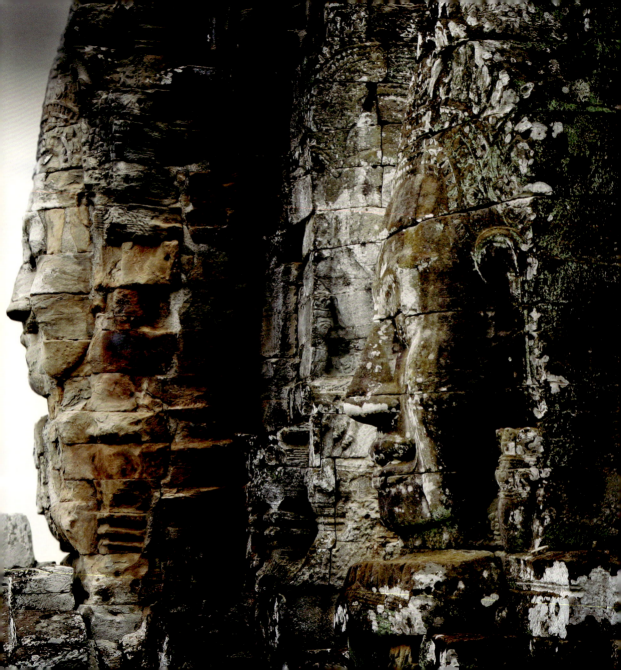

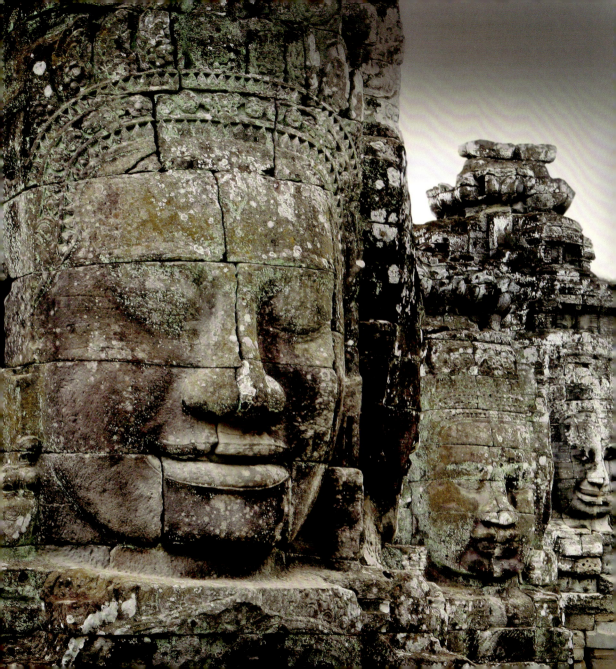

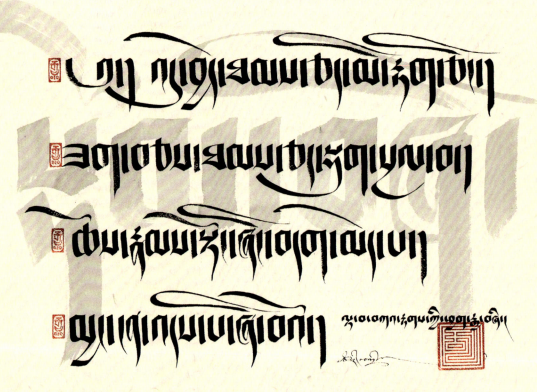

All that is, is impermanent;

All that is tainted is suffering;

All phenomena are empty and devoid of self;

Nirvana is peace.

— *The Four Seals*

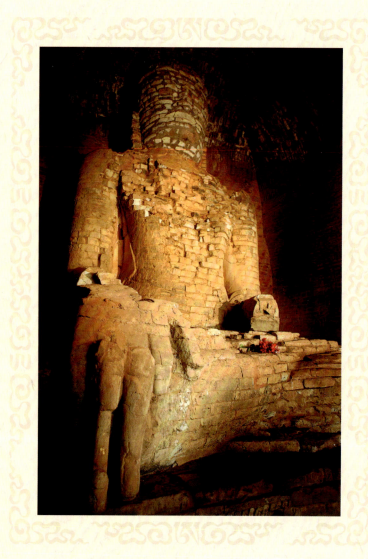

Impermanence
All things are impermanent and without self.

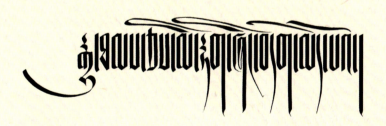

ཨེ་
ཪྒ་
པ

If you are concerned with improving your life, you are a materialist.

If you are concerned with how you are feeling, you don't want to be free.

If you are concerned with your own welfare, you are asleep.

If you are concerned with holding a position, you don't see.

— Sakya Kunga Nyingpo, The Four Concerns,

translated by Kenneth McLeod,

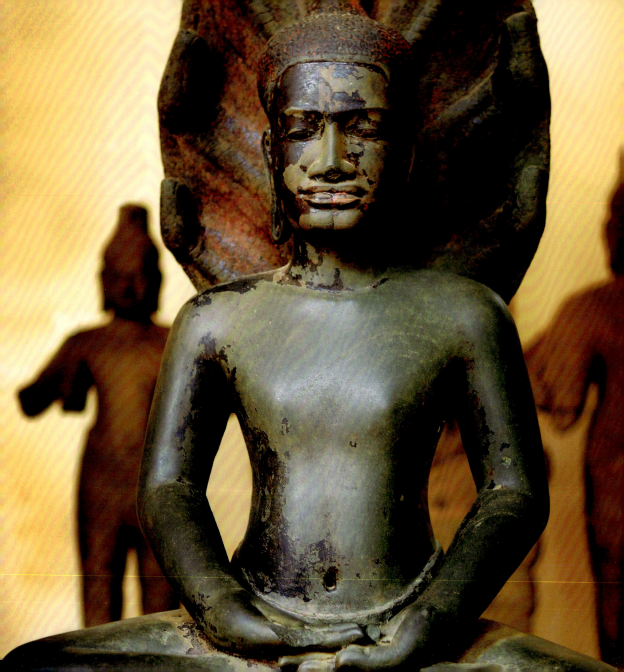

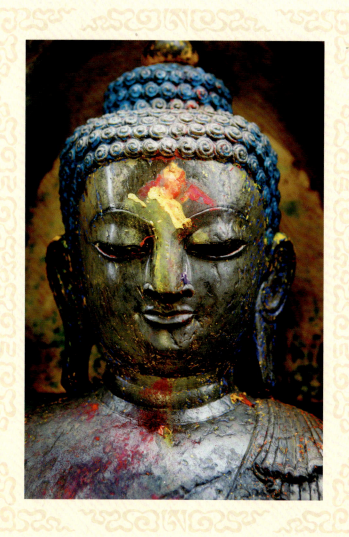

The Nature of Mind

Waves arise from water. In the same way, all phenomena are created by the nature of your mind, which is emptiness, arising as every kind of appearance.

— Pema Karpo, A Record of Mahāmudrā Instructions I, translated by Peter Alan Roberts

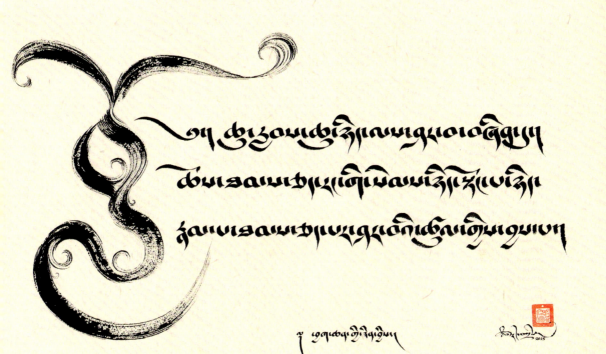

You Are What You Think

Our life is shaped by our mind; we become what we think.

With a clear mind, joy will follow our thoughts and actions like a shadow.

— *The Dhammapada*

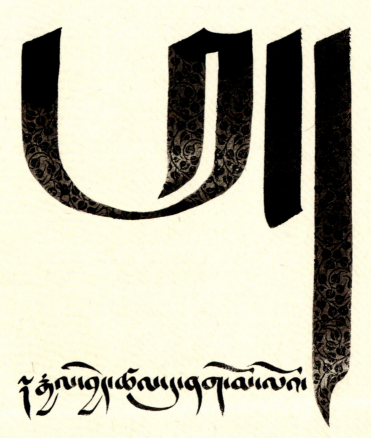

ཡ

རྫོགས་པ་ཆེན་པོ་ཀུན་ཏུ་བཟང་པོའི་ཀློང༌།

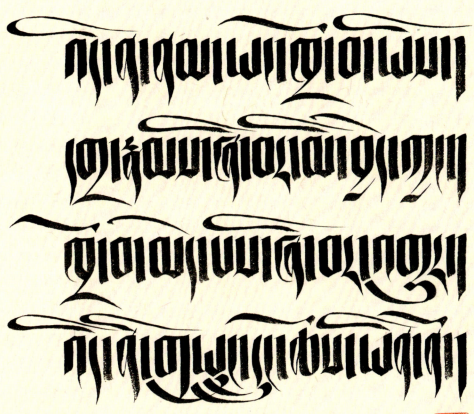

For hatred can never put an end to hatred; love alone can. This is an unalterable law.

— *The Dhammapada*

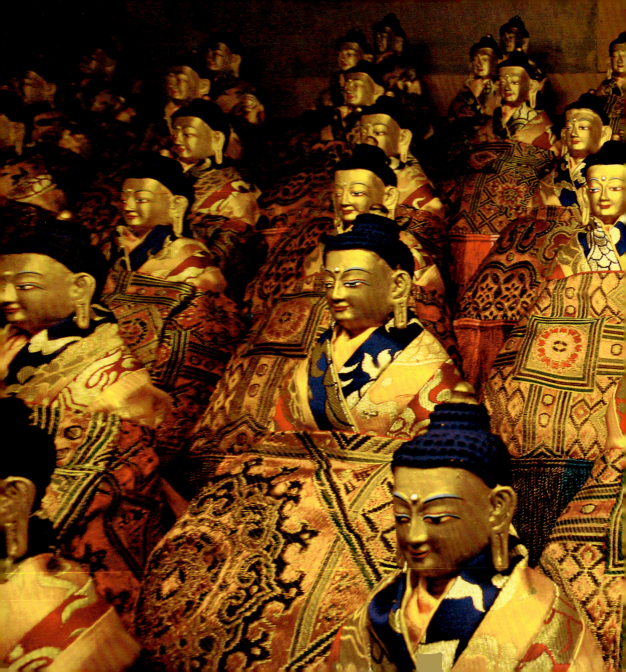

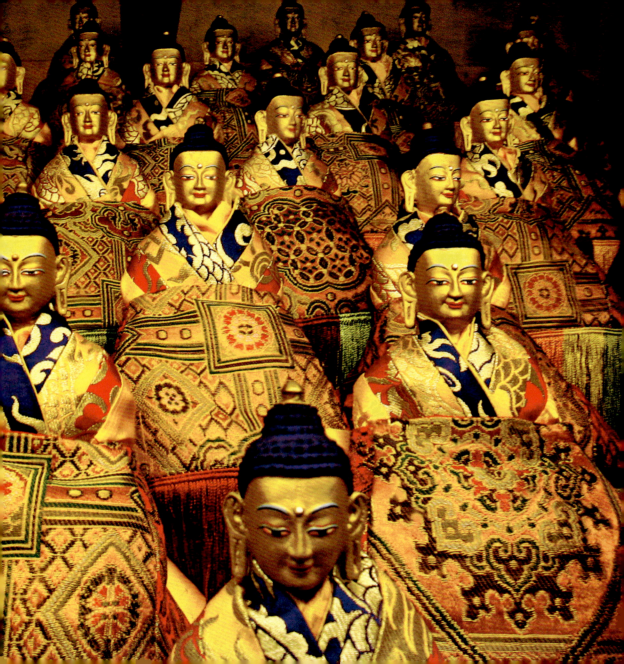

Serenity

All Dharmas are pure in nature; I am pure in nature.

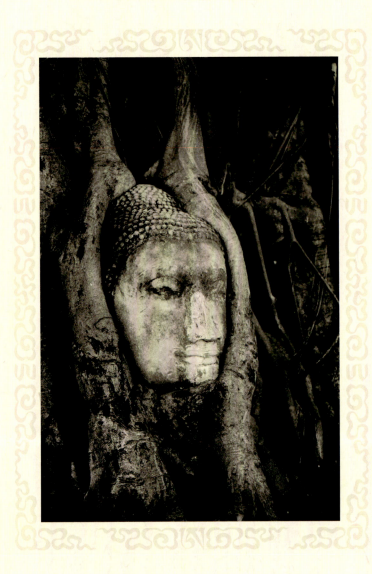

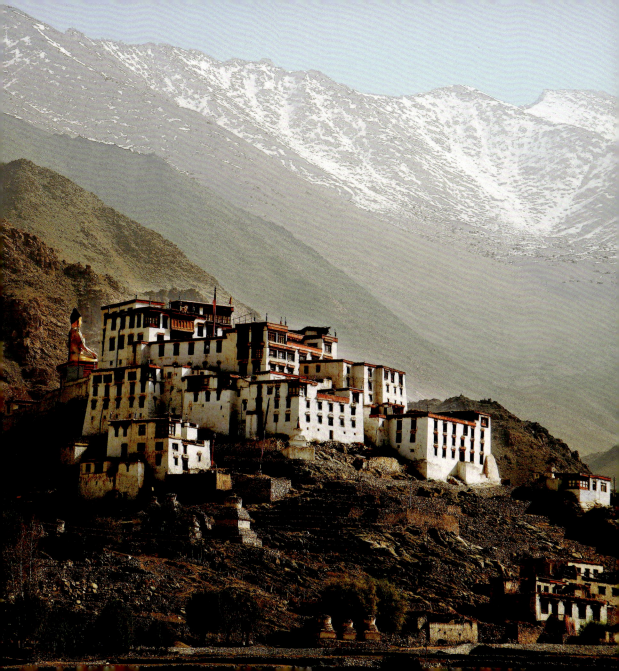

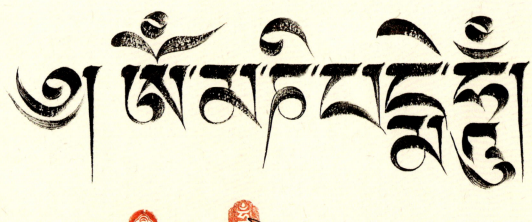

oṃ maṇipadme hūṃ

The Maṇi Mantra of Avalokiteśvara

The embodiment of loving kindness

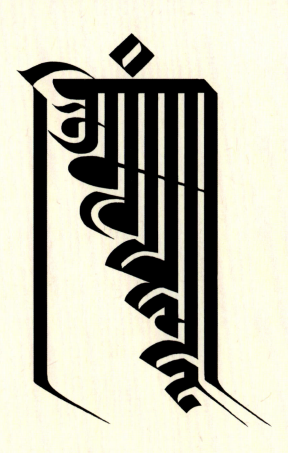

Mani Mantra monogram

Jetsun Pagma Drolma take heed;
Protect me from fear and suffering.

— The Green Tara Invocation Prayer

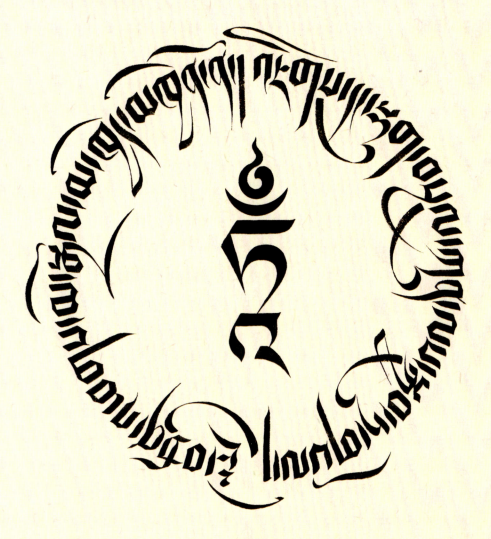

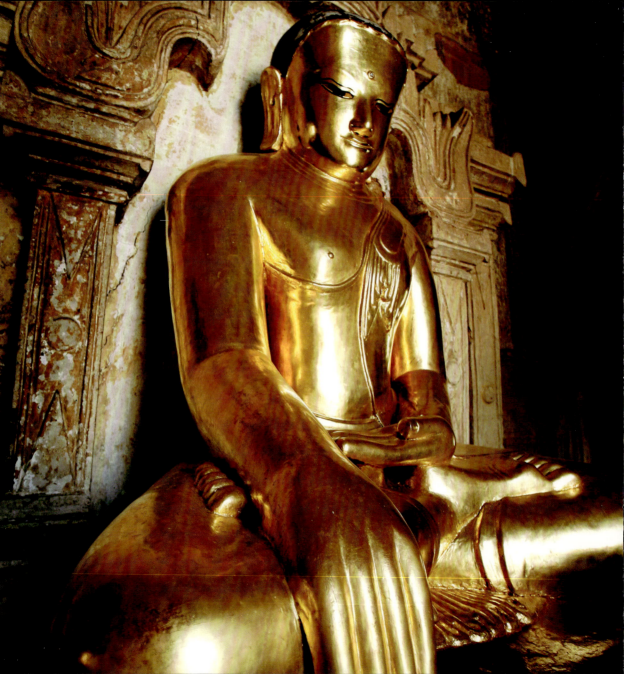

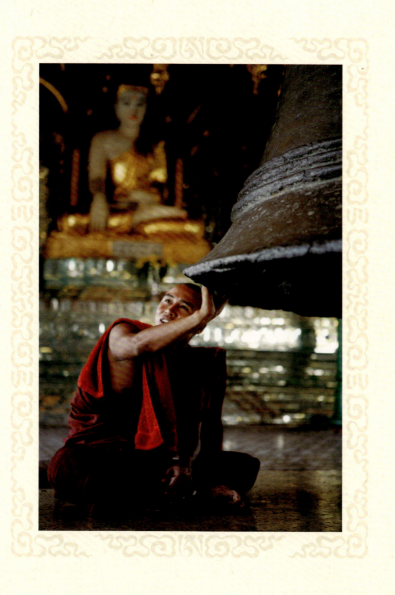

Grant your blessing so that my mind may follow the Dharma;

So that my Dharma practice may become the path;

So that the path may clarify confusion;

So that confusion may dawn as wisdom.

— The Four Dharmas of Gampopa

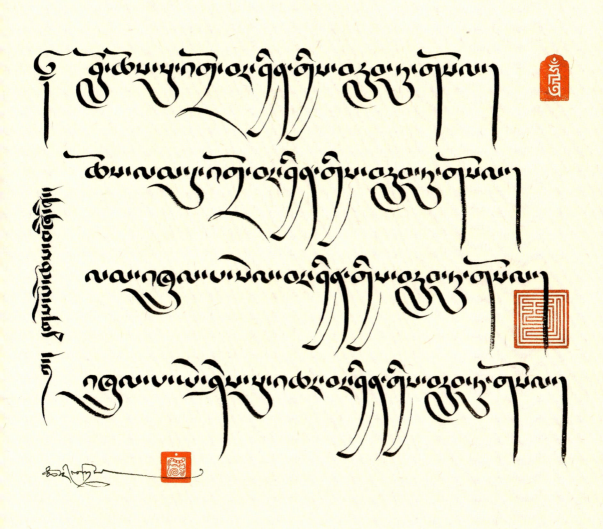

eh ma ho, en ma ho, chö

How Wonderful Is Dharma!

dhih

oṃ arapacana dhūḥ

— *Manjushri Mantra*

The one who cuts through ignorance.

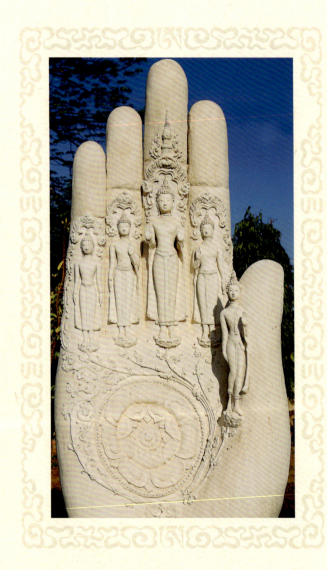

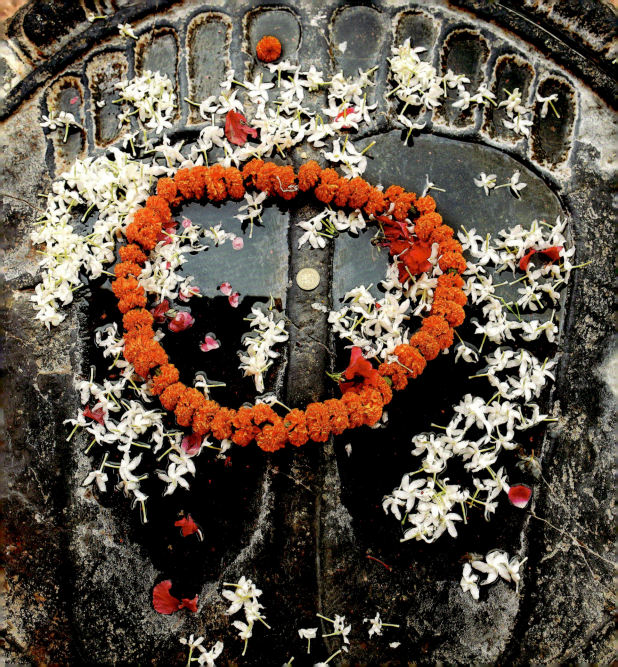

oṃ khecaraghana hūṃ hṛḥ svāhā

—*Tantra of Manjushri*

Say this mantra and blow on the soles of the feet, then
whatever animal dies beneath your foot will be reborn
in the land of thirty-three gods——so it is said.

༄༅། །ངག་ཁ་བར་ཇི་རྒྱལ་ལ།

ཨོཾ་བཛྲ་པཱ་ཎི་ཧཱུྃ་ཧྲཱིཿ་བཾ

དཔལ་ལྡན་ཀུན་ཏུ་བཟང་པོ་ནས་བརྒྱུད་པའི་བཀའ་ནན།

བཀའ་བརྒྱུད་ཆེན་པོ་རྣམས་ཀྱི་བྱིན་རླབས་ནུས་པའི་མཐུ།

ལ་སོགས་པའོ།

ༀ། ཆོས་ཀ་འབར་བ་ཀྱི་ཞི་བར་ཤ་འབར་ཏ་ཁ་ཇ་ཟག་པ།།

ཟི། ཐ་ད་པ་འཛིན་པ་འི་ང་ར་ཟལ་བ་མལ་ཞི་བ།།

ཐུ་ག་ན་ཀ་ན་ཚེ་ན་གྱི་ར་བ་ན་ཀྱུག་པ་པ་ཀ། ཕྱི།

ཡི་ཝ་ཚེ་ལ་བ་ཀྱི་ཏ་ཆ་ར་བ་ཚ་ཚ།

By this merit, may all beings attain Buddhahood;

May they overcome wrongdoing.

From the stormy waves of birth, old age, sickness, and death,

From the ocean of Samsara, may I free all beings.

— The Dedication Prayer of Merit

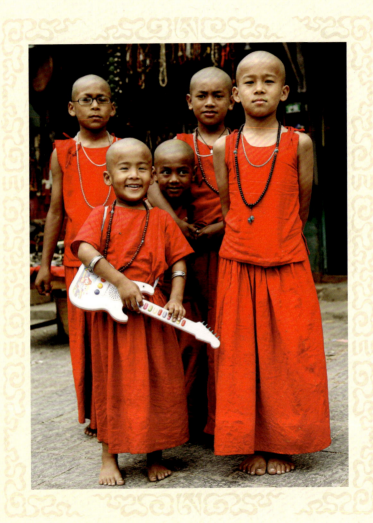

May goodness increase.

mangalam
Everything shall be auspicious.

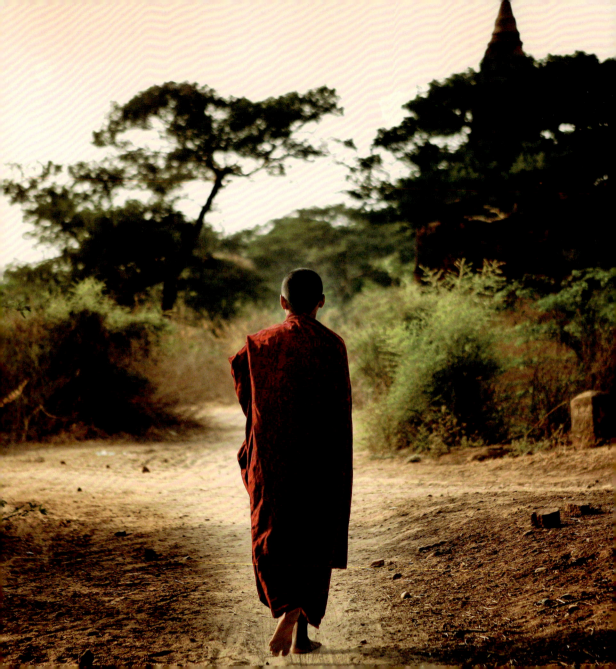

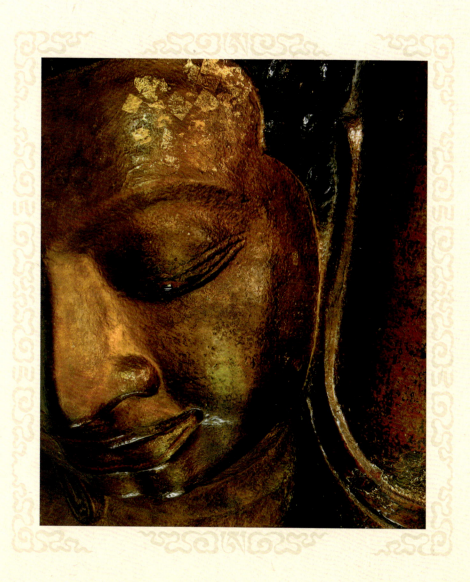

ART INDEX

64: Cambodia

65: Burma

66: oṃ *Blessing of Body*. Free brushed Umed script.

67: āḥ *Blessing of Speech*. Free brushed Umed script.

68: hūṃ *Blessing of Mind*. Free brushed Umed script.

69: Nepal

70–71: Laos

73: *The Four Immeasurable States*. Drutsa script.

74: *Awakened Mind*. Drutsa script.

76: Laos

77: Laos

79: *Mind*. A circle of Petsug script with the word "mind" at the center in Uchen script.

80: *Where Did It Come From? Where Did It Go?* Drutsa script.

82–83: Ladakh

84–85: *Practice What You Preach*. Uchen script.

87: *The Nature of Mind is Buddha*. Tsugtung script.

88–89: Cambodia

90: *The Four Seals of Buddhism*. Tsugtung script.

92: Sri Lanka

93: Sri Lanka

95: *All Things Are Impermanent and Without Self*. The larger calligraphy reads as "impermanence" in Petsug script, below which it reads "all things are Impermanent and without self" in Tsugring script.

96: *Four Concerns*. Drutsa script.

98: Cambodia

99: Nepal

101: *The Nature of Mind*. Tsugmakhyug script.

102: *We Are What We Think*. Ornate long-tailed Drutsa script.

104–105: *The Absence of Hatred Leads to Peace*. Short-tailed Tsugtung script with a large Bodhi-leaf-decorated heading character.

106–107: Tibet

108: *Serenity*. Classical Uchen script.

109: *Pure Nature*. Free-brushed Tsugmakhyug script.

110: Thailand

111: Ladakh

112: *The Mani Mantra*. The mantra of loving kindness, pronounced oṃ *maṇipadme hūṃ*. Free-brushed Uchen script.

113: *Mani Mantra Monogram*. The mantra of loving kindness, pronounced oṃ *maṇipadme hūṃ*, depicted as a Lantsa Sanskrit monogram.

115: Green Tara Prayer. The Green Tara mantra as a circle of calligraphy in the Tsugtung script. At its center is the seed syllable of Green Tara, *tāṃ*, in Uchen script.

116: Burma

117: Burma

119: *The Four Dharmas of Gampopa*. Fourteenth-century long-tailed Umed script.

120: *How Wonderful Is Dharma!* The Tibetan expression of wonder and amazement is uttered as eh ma ho. In this instance, it is directed at the wonderful Dharma: *eh ma ho, eh ma ho, Cho*. Brushed Uchen script.

123: *Manjushri Mantra with Dhīḥ Syllable on Lotus*. Upon an open lotus flower is the seed syllable of Manjushri, *dhīḥ*, and below that is Manjushri's mantra: oṃ *arapacana dhīḥ* in Petsug script style.

124: Thailand

125: India

127: *Underfoot Blessing*. Mantra in Uchen script, footnotes in Tsugmakhyug script.

128: *Dedication Prayer*. Petsug script.

130–131: Burma

132: Nepal

133: *May Goodness Increase*. Tsugmakhyug script.

134: *Auspicious*. A blessing that everything shall be auspicious. At the center of the circle of text is the Sanskrit word for auspiciousness: *maṅgalam*. The circle of calligraphy is in sixteenth-century long-tailed Umed script. *Mangalam* is in Uchen script.

136: Burma

137: Cambodia

138: Thailand

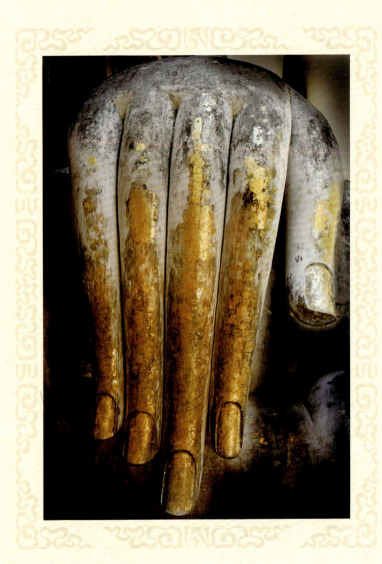

ABOUT THE ARTIST

TASHI MANNOX committed to his monastic journey after graduating with a BA in Fine Art (Hons) at the age of twenty-two. He spent the next seventeen years as a monk. Tashi apprenticed under the direction of a master of Tibetan art, Sherab Palden Beru, and also studied under Lama Pema Lodrup, one of the last Tibetan masters of the rare Lantsha and Wartu Sanskrit forms. Since laying down his monastic robes in 2000, Tashi has built on his disciplined training and spiritual awareness to produce a collection of iconographic masterpieces that reveal powerful, sacred themes through the majestic images of Tibetan Buddhist iconography. Tashi is now recognized as one of the world's foremost contemporary Tibetan calligraphy artists and exhibits internationally. To learn more, visit his website at www.tashimannox.com

ABOUT THE PHOTOGRAPHER

ROBIN KYTE-COLES has traveled extensively in South and Southeast Asia, capturing photographic images that reflect his deep interest in Buddhism and its teachings on compassion. His previous book, *The Spirit of Buddha*, was endorsed by His Holiness the Dalai Lama and took Kyte-Coles to remote spots in Vietnam, Laos, Cambodia, Thailand, Burma, Nepal, India, Tibet, and Sri Lanka.

MANDALA
PUBLISHING

PO Box 3088
San Rafael, CA 94912
www.mandalaeartheditions.com

Find us on Facebook: www.facebook.com/MandalaEarth
Follow us on Twitter: @MandalaEarth

ISBN: 978-1-60887-879-6

PUBLISHER: Raoul Goff
CO-PUBLISHER: Michael Madden
ACQUISITIONS MANAGER: Robbie Schmidt
ART DIRECTOR: Chrissy Kwasnik
DESIGNER: Jenelle Wagner
EXECUTIVE EDITOR: Vanessa Lopez
PROJECT EDITOR: Courtney Andersson
PRODUCTION EDITOR: Rachel Anderson
PRODUCTION MANAGERS: Thomas Chung and Alix Nicholaeff

Mandala Publishing, in association with Roots of Peace, will plant two trees for each tree used in the manufacturing of
this book. Roots of Peace is an internationally renowned humanitarian organization dedicated to eradicating land mines
worldwide and converting war-torn lands into productive farms and wildlife habitats. Roots of Peace will plant two million
fruit and nut trees in Afghanistan and provide farmers there with the skills and support necessary for sustainable land use.

Manufactured in Hong Kong by Insight Editions

10 9 8 7 6 5 4 3 2

SWAMI in a STRANGE LAND

HOW KRISHNA CAME TO THE WEST

The Biography of
A.C. Bhaktivedanta
Swami Prabhupada

Joshua M. Greene

Foreword by
Klaus K. Klostermaier, PhD

RADHANATH SWAMI

The Journey Within

EXPLORING THE PATH OF BHAKTI

A Contemporary Guide to Yoga's Ancient Wisdom

NAME _____

ADDRESS _____

CITY _____

STATE _____ ZIP _____

COUNTRY _____

EMAIL _____

STAMP
HERE

MANDALA
P U B L I S H I N G

PO BOX 3088
SAN RAFAEL, CA 94912